100
Claude Monet
Masterpieces

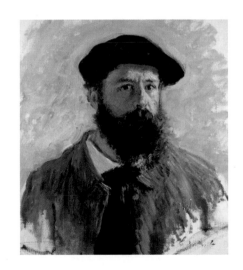

Publisher and Creative Director: Nick Wells
Project Editors: Chelsea Edwards and Polly Prior
Art Director: Mike Spender
Layout Design: Nik Keevil
Digital Design and Production: Chris Herbert

Special thanks to: Laura Bulbeck, Catherine Taylor and Digby Smith

11 13 15 14 12
1 3 5 7 9 10 8 6 4 2

This edition first published 2011 by
FLAME TREE PUBLISHING
Crabtree Hall, Crabtree Lane
Fulham, London SW6 6TY
United Kingdom

www.flametreepublishing.com

Flame Tree Publishing is part of The Foundry Creative Media Co. Ltd

© 2011 this edition The Foundry Creative Media Co. Ltd

ISBN 978-0-85775-250-5

A CIP record for this book is available from the British Library upon request.

Every effort has been made to contact copyright holders. We apologize in advance for any omissions and
would be pleased to insert the appropriate acknowledgement in subsequent editions of this publication.

While every endeavour has been made to ensure the accuracy of the reproductions of the images in this book,
we would be grateful to receive any comments or suggestions for inclusion in future reprints.

Printed in China

100
Claude Monet
Masterpieces

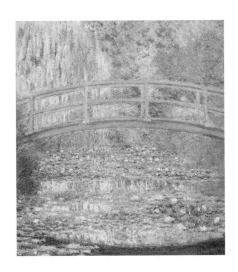

Gordon Kerr

FLAME TREE
PUBLISHING

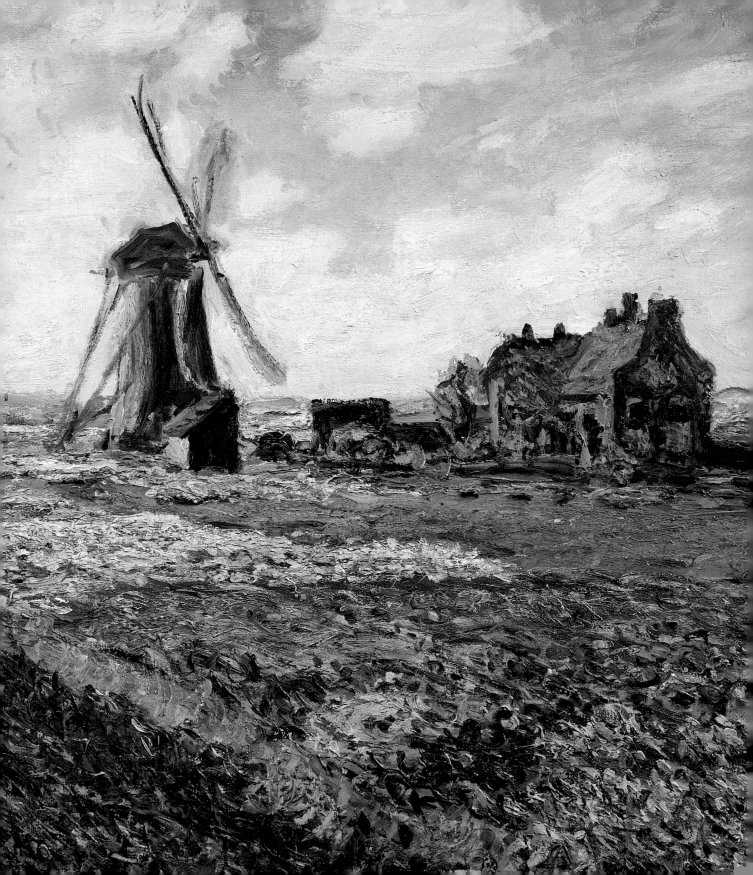

Contents

Life

ARGUABLY, THE GREATEST OF THE Impressionists was Claude Monet (1840–1926), from whose painting, *Impression: Sunrise* (*see* page 67) the movement derived its name. In a career blighted for many years by rejection by the art establishment and desperate poverty, he virtually defined the Impressionist style. His stunningly beautiful paintings helped to define the way in which we see nature and the world around us, and prepared the way for a great deal of twentieth-century art.

He remains one of the best-loved, as well as one of the most important, painters in the modern Western artistic tradition.

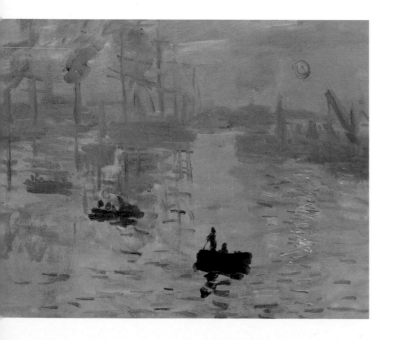

The Emerging Artist

❧ **Oscar Claude Monet** was born in Paris, on 14 November 1840, the second son of Claude Adolphe and Louise-Justine Monet. At the age of five, he moved with his family to Le Havre on the Normandy coast where his father had become a partner in the family wholesale grocery business.

Early Interest

❧ At school in Le Havre, Monet was interested only in drawing, creating caricatures of his teachers and fantastic creatures in the margins of his schoolbooks. Most of his free time was spent wandering on the nearby beaches, filling his notebooks with sketches of sailing ships. As he himself admitted, 'I was born undisciplineable. No one was ever able to make me stick to the rules, not even in my youngest days. It was at home that I learned most of what I do know. I equated my college life with that of a prison and I could never resolve to spend my time there, even for four hours a day, when the sun was shining bright, the sea was so beautiful and it was so good to run along the cliff-tops in the fresh air or frolic in the sea.'

❧ By the age of 16, Monet was well known locally for the charcoal caricatures he drew. '...I became someone of importance in the town. There, along the shop front of the only framers in business at Le Havre, were my caricatures ... under glass like real works of art. Moreover, when I saw strollers gathering to gape at them with admiration and cry, "It is so and so!" I was bursting with pride.' He was being paid 20 francs for each picture, money that he handed over to his aunt for safekeeping.

❧ His drawings were displayed alongside the landscapes of Eugène Boudin (1824–98), who would become an important figure in Monet's development. Monet was initially not keen on Boudin's work and was a reluctant convert. Boudin, however, recognized and encouraged Monet's obvious talent and, crucially, introduced the young artist to painting outdoors (in French, *en plein air*). Outdoor painting was a revelation to Monet and from that moment it was the only way he wanted to work.

Discovering Paris

In April 1859, aged 18, Monet set off for Paris, using the money he had saved up from the sale of his caricatures as well as a small allowance provided by his father. He arrived in time to visit the Salon: the official art exhibition of the Académie des Beaux-Arts and the most important event in the Western art world at that time. It must have been a dazzling experience for the young artist. Thousands visited every day and, as it was the main way to achieve recognition and find buyers, every artist wanted to have work exhibited there. Unfortunately, however, the judges were painters and teachers of the old school, rigid advocates of the Classical style. Nonetheless, Monet still found some paintings that he greatly admired, especially, as he excitedly wrote to Bourdin, those of a couple of landscape painters – Constant Troyon (1810–65) and Charles-François Daubigny (1817–78).

A month after his arrival in Paris, Monet's father stopped his son's allowance and ordered him home but Monet refused, telling his father that the money he had earned from his caricatures would tide him over for a while. He rented a cheap room on the Place Pigalle and began mixing with the artists and writers who frequented the bars and cafés of that bohemian quarter of Paris.

He elected to study at the Académie Suisse, run by former artist's model Père Suisse, who provided an informal environment in which artists could work without any input or criticism from a teacher. They were free to use whatever medium they wished and were allowed to draw from life, something that was not permitted in the more formal schools until the student spent many years drawing plaster casts of Classical sculptures.

The Artist's Struggle

In the spring of 1861 this way of life ended abruptly for Monet, when he was selected in France's lottery-style military draft. His father offered to buy him out of the army, but only on condition that he give up his life as an artist and return home to work in the family business. Monet rejected the offer.

Life in the Army

Drafted into the African Light Infantry, he was posted to Algeria, arriving there in June 1861. He may have been bored by the military routine, but he was delighted by the alien landscape, the dazzling sunshine and the exotic light and colour. 'There were new sights to be seen all the time,' he said, 'and in leisure

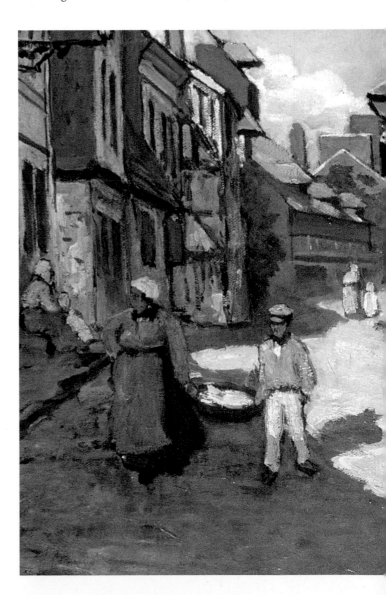

moments I tried my hand at rendering them. You can't imagine how much I learned in this way, how well it trained my eye. I wasn't aware of it myself at first. The impressions of light and colour that I received down there only got sorted out later, but the seeds of my future work had already begun to sprout.' After just over a year, stricken with typhoid, Monet was shipped back to Le Havre. During his recuperation, he met another man who would be important in his artistic development – the Dutch painter Johan Barthold Jongkind (1819–91), who was staying in the nearby town of Honfleur. 'It is to him that I owe the final education of my eye,' Monet later said.

French painting experienced a momentous year in 1863. The number of works rejected by the Salon judges created such a furore in the art world that Emperor Napoleon III insisted on going to the Salon to see for himself what all the fuss was about. Declaring the rejected pictures to look no worse to him than the ones that had been accepted, he ordered that the rejects be hung in another part of the Palais de l'Industrie so that the public could judge them for

themselves. This exhibition came to be known as the Salon des Refusés. One work exhibited there created a scandal. Édouard Manet's *Luncheon on the Grass* depicted a picnic with two women, one of them nude, and two fully clothed men. Its daring subject matter and dramatically contrasting colours set it apart from everything else in the exhibition and delighted Monet and his friends.

Salon Recognition

In 1864, when Gleyre suddenly closed his studio, Monet returned to Le Havre, where his aunt and his father harangued him about his failure to sell anything. Monet ignored them, returning to Paris where he at last gained some recognition for his work. Not only did the judges for the 1865 Salon accept two of his paintings – *La Pointe de la Hève* (*see* pages 42–43) and *L'Embouchure de la Seine à Honfleur* – but critics also praised the works, one describing them as the best seascapes in the exhibition. Better still, both paintings sold for 300 francs each.

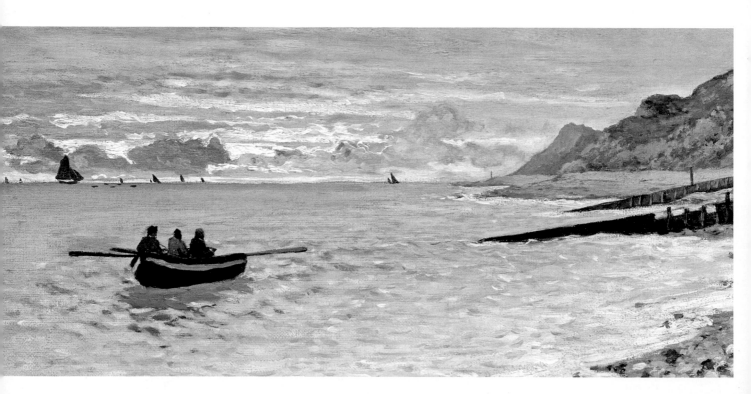

Flushed with this success, Monet planned an audacious painting, *Luncheon on the Grass* (*see* page 46), inspired by Manet's scandalous work of the same name. It was to feature a picnic attended by 12 people and would be painted *en plein air*, using natural light and an authentic woodland backdrop. No one had ever attempted to execute such a painting outside of a studio. This was a difficult and complex project and before long Monet was forced to go against his own instincts and work on the painting in the studio, having made sketches outside. Sadly, it was later damaged by damp and only two fragments remain.

Monet's Model

The deadline for submissions to the 1866 Salon was fast approaching and he had nothing to offer. In just four days he painted *The Woman in the Green Dress* (*see* page 48), a painting of a woman in a green and black striped skirt, casting a backwards glance over her shoulder. It was accepted and was well reviewed by critics. The model for the painting was the beautiful 18-year-old Camille-Léonie Doncieux, with whom, to the outrage of Monet's family, he was now living. His furious father once again stopped his son's allowance.

Twenty-five years old and with no money, Monet decided to escape his creditors by moving with Camille to Ville d'Avray, a village to the west of Paris. There, he began another large painting, *Women in the Garden* (*see* page 50), in which four women – all posed by Camille – were shown around a tree in a garden. Painting outdoors, Monet solved the problem of how to reach the upper sections of the canvas by digging a trench into which he could lower it. His creditors, however, were hot on his heels and, forced once again to move due to their inability to pay the rent, the couple set up home in Le Havre. Monet's father, however, still refused to meet Camille.

Camille Falls Pregnant

Monet's financial problems were compounded when Camille became pregnant. To add to his despair, *Women in the Garden* was rejected by the jury of the 1867 Salon, who were troubled by Monet's visible brushstrokes and what they considered to be its weak subject matter. He would take his revenge for this rejection 52 years later by charging the French state 200,000 francs for it.

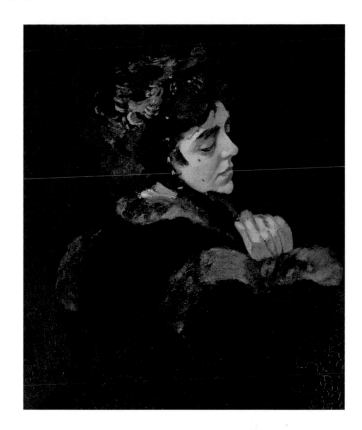

It was a terrible time. The pregnant Camille was unwell and when Monet turned to his father for help, he refused unless Monet gave her up. In desperation, Monet pretended to do as his father asked. Leaving Camille in Paris, he spent the summer in Le Havre, arguing with his father and living with his aunt Marie-Jeanne at Sainte-Adresse. Amongst the paintings he completed that summer was *The Terrace at Sainte-Adresse* (*see* page 53), which shows his father, his aunt, his cousin and an unknown man.

Jean Monet is Born

Sadly, Monet was not present at the birth of his first son, Jean-Armand-Claude Monet, on 8 August 1867, but his aunt bought him a train ticket so that he could at least visit Camille and the baby. Happily, the sale of *The Woman in the Green Dress* allowed him to return to Camille and his son in Paris, but they remained short of money throughout the winter of 1868. That year's Salon brought good news, with the acceptance of *The Jetty of Le Havre* (*see* page 55). However, despite critical acclaim, it remained unsold.

Portrait Commission

Desperate for money once again, there was relief when the wealthy businessman Louis Joachim Gaudibert asked Monet to paint portraits of him and his wife, including *Portrait of Madame Louis Joachim Gaudibert* (*see* page 54), which is treated as a formal, academic portrait but shows its subject turning her head away from the viewer, introducing an unexpected, casual informality. Monsieur Gaudibert also purchased a couple of seascapes, allowing Monet and Camille to enjoy an unfamiliar period of financial security. They moved to Fécamp on the Normandy Coast.

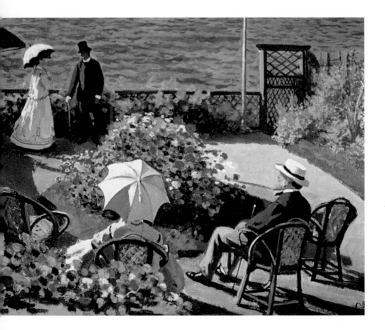

Hard Times

Monet's two submissions to the 1869 Salon were rejected but, undeterred, he made plans to paint by the Seine that summer in the company of his friend, Renoir. The family took lodgings near Bougival but could barely afford food.

Monet had conceived a large, new painting of a boating, bathing and dining spot near Bougival – *La Grenouillère* ('The Froggery') (*see* page 57). If any painting echoed the urging of the writer and poet Charles Baudelaire (1821–67) that the artist should be a passionate spectator of modern life, it is this one. In it, Monet painted ordinary people enjoying their leisure time at the floating restaurant.

By the September of 1869, Monet could not even afford to buy paints. Meanwhile, his lack of favour with the Salon continued. The jury of the 1870 Salon accepted work by his friends Renoir, Sisley, Camille Pissarro (1830–1903) and Bazille, but, to Monet's despair, rejected his.

Escaping to London

Monet and Camille finally married in the summer of 1870, but it made little difference to his father and his aunt, who continued to ignore his new wife. But soon their lives were in turmoil. Fearing the military draft when France and Prussia went to war in July 1870, Monet fled to England, with Camille and Jean joining him later. Paintings such as *The Thames Below Westminster* (*see* page 63) show the beginnings of his fascination with the foggy River Thames. While there, however, he learned that his old friend and benefactor, Frédéric Bazille, had been killed in battle.

In London Monet met the Parisian art dealer Paul Durand-Ruel (1831–1922) – one of the most important introductions of his career. Durand-Ruel bought several paintings from Monet and began to represent him.

Monet might have expected his financial situation to be eased on the death of his father in January 1871, but Claude Adolphe Monet had married his long-term mistress not long before he died and left the majority of his wealth to her and their daughter.

Return to France

In the autumn of 1871, Monet, Camille and Jean returned to France where they rented a little house near Argenteuil, a short train journey from Paris on the Seine. Monet built a floating studio and painted 46 pictures in his first year there. His work at Argenteuil could, indeed, be said to represent the essence of Impressionism, as is evident in paintings such as the famous *Wild Poppies, Near Argenteuil* (*see* page 75), painted in 1873.

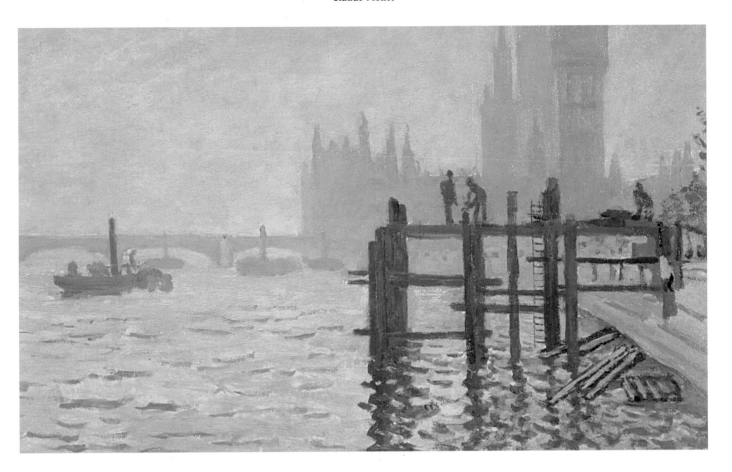

With Durand-Ruel's return to Paris, Monet's financial affairs improved greatly and for the first time he began to earn real money – as much as 25,000 francs in 1873. His contentment showed in his work, but this was to be short-lived as Durand-Ruel's business began to decline.

Banding Together

Constant rejection by the Salon made life difficult not only for Monet, who had not submitted anything since 1870, but also for other painters of the same artistic persuasion. These included his friends Sisley, Renoir and Pissarro, but also others such as Paul Cézanne (1839–1906), Edgar Degas (1834–1917) and Berthe Morisot (1841–95) were being shunned, too, by the art establishment. In one of the most important moments in the history of modern art, this group of disgruntled artists decided to stage their own exhibition.

Thirty artists of the *Société Anonyme Coopérative des Artistes Peintres, Sculpteurs, Graveurs* ('Co-operative and Anonymous Association of Painters, Sculptors and Engravers') launched their first show in April 1874 in the studio of the photographer Nadar (1820–1910). However, few pictures sold, attendance was poor and those who did turn up left confused and sometimes angry. Reviewing the show in the newspaper *Le Charivari*, critic Louis Leroy made fun of Monet's painting *Impression: Sunrise*, unintentionally providing a name for the movement in the process. 'Impression – I was certain of it,' he wrote, 'I was just telling myself that, since I was impressed, there had to be some impression in it … and what freedom, what ease of workmanship! Wallpaper in its embryonic state is more finished than that seascape.' From then on, like it or not, they were 'Impressionists'.

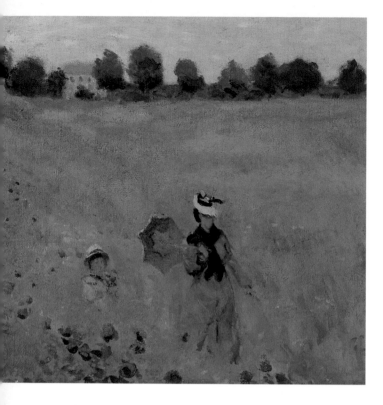

Monet Meets the Hoschedés

In autumn 1876, with Camille ill, Monet was commissioned by wealthy art collector Ernest Hoschedé (d. 1891) to paint panels in a room at his château. The Hoschedés, especially Ernest's wife, Alice, would play a very big part in the remainder of Monet's life.

That same year, he began work on a sequence of paintings depicting a significant modern subject – the Gare Saint-Lazare, one of Paris's new railway stations. He completed 12 paintings of the station, capturing the excitement, noise, bustle and colours of this new phenomenon in works such as *The Pont de l'Europe, Gare Saint-Lazare* (*see* page 94).

Personal Tragedy

The year 1877 was terrible. At one point Monet was forced to sell 10 paintings to a dealer for only 1,000 francs. He begged his friends and associates for financial help, but eventually was left with little option but to give up the house in Argenteuil. Yet again, the Monet family was on the move, this time to Paris.

He was not the only one in desperate financial straits, for, in 1878, Ernest Hoschedé was declared bankrupt. Hoschedé fled to Belgium, leaving his pregnant wife Alice and their five children behind in France to fend for themselves.

Meanwhile, Camille gave birth to a second son, Michel, in March 1878 and Édouard Manet helped a despairing Monet by providing him with a loan and helping him to find a cheaper place to live in Vétheuil, by the Seine, near Paris. The Hoschedés, all eight of them now, including Ernest who had returned from Belgium, also moved in. But Monet was earning little and Hoschedé contributed nothing to the household.

Camille's Health Deteriorates

A cold winter did little for Camille's health and Alice Hoschedé nursed her, while the artist Gustave Caillebotte (1848–94) proved himself a loyal friend by providing Monet with funds. The fourth Impressionist exhibition passed with the customary vitriol from the critics.

On 5 September 1879, Camille, emaciated and in terrible pain, succumbed to cancer, aged just 32. Monet later recalled how, following her death, he was appalled to find himself studying her lifeless face with the dispassionate eye of the artist. 'I found myself staring at those tragic features and automatically trying to identify the sequence, the gradation of colour that death had imposed on the motionless face ... even before the thought occurred to me to memorize the face that had meant so much to me, my first involuntary response was to tremble at the shock of the colours.'

The following winter was again bitterly cold and the extended Monet family survived on hand-outs from the generous Caillebotte and Monet's brother Léon. Reflecting the bleakness of his life at the time, he painted the frozen waters of the Seine – works that seemed to be even more unfinished than anything to date, stark and semi-abstract.

Financial Success

❧ **After a gap** of 10 years, Monet horrified his friends by submitting to the 1880 Salon and of the two pictures he sent, one was accepted. It would be his last submission. Soon after, however, he was the subject of a one-man exhibition staged at the offices of the weekly arts review *La Vie Moderne*. The critics were slowly warming to his approach to landscape painting. 'Claude Monet is the one artist since Corot [Jean-Baptiste-Camille Corot (1796–1875)] who has brought inventiveness and originality into landscape painting,' wrote the critic Théodore Duret (1838–1927). It seemed to mark a turning point in his career, as from that time on his paintings began to sell.

❧ As can be seen in much of Monet's work of the 1880s, such as *The Customs Officers' Hut at Varengeville* (*see* page 106) or *Boats on the Beach at Etretat* (*see* page 108), he made numerous journeys to Normandy's coastal resorts – Fécamp, Etretat and the area around Dieppe – to render in paint the dramatic coastline. Some of this travel was funded by a resurgent Durand-Ruel, who recognized that Monet's seascapes were amongst his most popular, and therefore most commercial, works.

❧ In 1881, in search of a good school for his son Jean, Monet decided to move to Poissy, closer to Paris. Scandalously, Alice Hoschedé elected to go with him, leaving her husband Ernest from whom she had become estranged. Poissy, however, was not a happy place for the artist and Monet resolved to move yet again. This time, however, he was determined to find a place where he could settle down, where his and Alice's large family could be happy and, above all, where he could work.

Giverny

❧ **Monet first saw** the village of Giverny from the window of a train in the spring of 1883. There he found a large, rambling farmhouse to rent in two acres of land, with a walled garden and an *allée*, a broad walk edged with cypress trees and spruce. The garden led down to railway lines on the other side of which

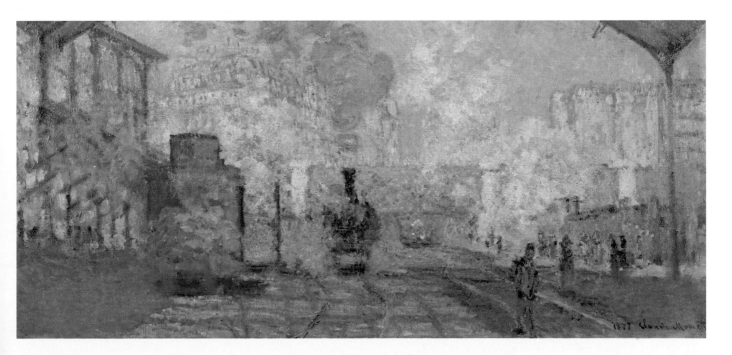

ran the small River Ru. On the nearby Seine he moored his four boats, including two skiffs that became the subjects of several paintings such as *The Boat at Giverny* (*see* page 115).

- He turned one of the two barns into a studio and set to work on the creation of one of the world's most famous gardens, planting vegetables and flowers, digging up trees and planting roses that were trained up the metal arches that he installed along the length of the *allée*.

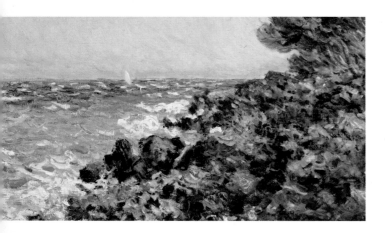

- Despite his attachment to his garden, Monet continued to travel and, in January 1884, he journeyed south to the Mediterranean coast. Amongst the works of this trip that, in some ways, prefigured the anguished painting of Vincent van Gogh (1853–1890) was *Cap Martin* (*see* page 111), which announced a new boldness in Monet's painting and a startling brilliance of colour – a deep cobalt sea amidst a panoply of hot, southern hues. On another southern sojourn in 1888, his work was more subtle and elegant. Of paintings such as the *Old Fort at Antibes* (*see* page 116), the poet Stéphane Mallarmé (1842–98) told the artist, 'This is your finest hour.'

- The contentment that Monet found at Giverny brought a change in his work. Furthermore, 1886 was an important year for the art of the time: Georges Seurat (1859–91) completed his ground-breaking painting *A Sunday Afternoon on the Island of La Grande Jatte*, the work that signalled the beginning of Neo-Impressionism; Paul Gauguin (1848–1903) made his first visit to

the artists' colony at Pont-Aven; the short-lived review *Le Symboliste* was founded; and Vincent van Gogh arrived in Paris. For Monet, it also brought a significant change: a relaxation in his work, reflecting the lyricism of his life at Giverny.

Working in and Around Giverny

- He decided to spend the autumn of 1890 at home, to paint what would become a series of depictions of one motif – the uniquely shaped *meules* or haystacks in fields near his house. These would perhaps mark the highpoint of his efforts to capture the transient magnificence of light. He exhibited 15 to great acclaim at Durand-Ruel's gallery in 1891.

- Monet now often painted in series, detailing the fleeting effects of light on nature. In 1891, he created 25 paintings of a field of poppies and then began work on poplar trees growing along the Epte River.

- In 1891, Ernest Hoschedé died and Alice was at last free to marry Monet. With his paintings selling for as much as 15,000 francs each, he was able to buy the Giverny farmhouse. He extended the garden, importing exotic plants, building greenhouses and devising complex planting schemes. Giverny gradually became famous, with painters arriving from all over the world. At one time, more than 40 American artists were working there. Monet, now a celebrity, ignored them all.

- In 1893, he travelled to Rouen where he executed a series of paintings depicting the façade of the city's imposing Gothic cathedral, such as *Rouen Cathedral in the Setting Sun* (*see* page 121). This would become one of his most renowned painting cycles, documenting the fall of light on the façade of the structure in an astonishing series of 30 canvases.

- His career-long fascination with atmosphere and architecture finally ended with two projects. In 1899, 1900 and 1901 he made winter visits to London, painting the panorama of the often fog-shrouded Thames. The second project was undertaken during two visits to Venice, in 1908 and 1909, where Monet was entranced by the light he encountered.

Water Lilies

❧ **Monet had bought** a parcel of land on the other side of the railway line at the bottom of his garden at Giverny. In a small pond there, he planted new hybrid types of water lilies and over the pond built a bridge – seen in his 1899 painting *The Waterlily Pond with the Japanese Bridge* (*see* page 126) – whose design was borrowed from the Japanese prints he had collected over the years. In 1901, he greatly increased the size of the pond and filled it with water lilies. It became the template for his last great challenge – a series depicting the water lilies and the water in which they grew, but above all showing the effects of the light and atmosphere upon them.

❧ In 1909, when Durand-Ruel exhibited 48 of Monet's water lily paintings, they were received rapturously by the critics, many of whom suggested that the series should be kept together. Monet agreed. He had already conceived of a circular room in which they should be displayed.

Personal Difficulties

❧ There were personal trials ahead, however. In May 1911, Alice died of leukaemia and Monet, now 70 years old, was distraught. A few months later he learned that he had cataracts on his eyes. They did not necessitate immediate surgery, but his vision was impaired, especially his sense of colour.

❧ Assisted by Blanche Hoschedé, the second daughter of Ernest and Alice, who looked after her stepfather until his death, Monet persevered with the water lily paintings, despite his failing vision, and in 1914 built a new studio big enough to hold the large panels. By 1918, he had completed 30 paintings, but although everyone adored them, he refused to part with them. Only when victory in the First World War was announced did he write to his old friend, French prime minister Georges Clemenceau, to offer two of the panels to the nation in celebration of her victory. When Clemenceau suggested that Monet donate the entire project to the nation, the artist agreed to hand over 12 water lily panels, but only on condition that they be displayed in a circular

or oval setting. Finally, the Orangerie, a building near the Louvre in Paris, was agreed upon and in 1922, Monet signed the contract.

❧ His eyesight was now failing badly and he agreed to an operation. By September 1923, his vision was much improved, although he was still having problems with colours. He remedied this by working very close to the surface of the canvas.

❧ Monet kept re-painting the water lilies and even when the re-design of the Orangerie was completed, he still would not part with them. During the winter of 1925–26, however, his lifelong chain-smoking caught up with him when he was found to be suffering from lung cancer. Claude Monet died, aged 86, on 5 December 1926 and the water lilies finally became the property of France.

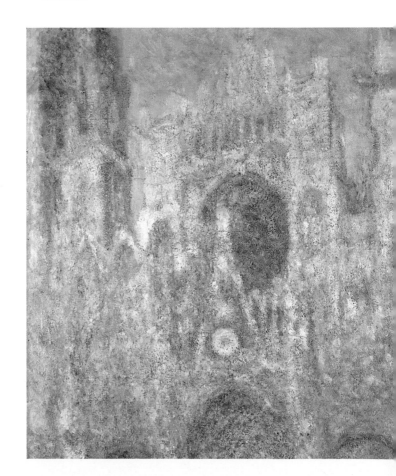

Society

ONET WAS BORN AT A TIME OF tremendous change in France: industry was beginning to take hold, towns were being enlarged, transport networks were expanding, roads were being improved and the development of railways was opening up the interior. It was a time of growth, of the rapid expansion of the middle classes and also of political upheaval. Increasing wealth resulted in massive consumerism and a capitalist society that was nevertheless anxious about the acquisition of wealth and status. The collection of art and the practice of art classes formed an important part of this bourgeois society and the background to Monet's development.

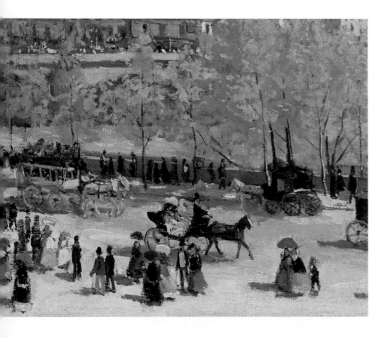

Fellow Artists

➣ **Like all great** artists, Claude Monet mixed with and was influenced by a great many other artists. The first of these, and arguably the most important of all, was Le Havre native Eugène Boudin, who was primarily a marine painter and one of the first French landscape painters to work outdoors. Boudin came from a seafaring family and is best known for his paintings of the sea and sky, although he has sometimes disparagingly been described as 'the painter of beaches'. He worked directly from nature on the coast of Normandy and, with his concern for the depiction of light in changing weather conditions, his strokes of pure colour and his delicate brushwork, he can in many ways be said to prefigure the Impressionists, who held him in great respect.

The Influence of Boudin

➣ Boudin first encountered Monet in Le Havre around 1857–58, where the work of both men – Monet's caricatures and Boudin's landscapes – hung alongside each other in a small art-supply shop in the town's Rue de Paris. Boudin, 15 years older than Monet, told the younger man that he did, indeed, have talent but that he would soon tire of caricatures and should broaden his horizons by undertaking the study of art and by creating some landscapes. Monet liked Boudin but was less keen on the man's work, and it was some time before he could finally be persuaded to accompany Boudin on a painting expedition. Boudin's advice to Monet, however, would set the tone for the rest of his career.

➣ Monet realized that, to become an artist, he would have to go to Paris to study the art being exhibited in galleries and to visit artists' studios. From Paris he wrote to Boudin, describing the work he was seeing.

➣ Like many proto-Impressionists, Monet was particularly keen on the work of the leader of the French Romantic school, Eugène Delacroix (1798–1863), about which he wrote to Boudin, 'They are only jottings, rough sketches, but as always what vitality,

what movement in them!' Delacroix's disjointed, expressive brushstrokes and his preoccupation with colour-induced optical effects provided a foretaste of the Impressionists' efforts to convey the transient effects of light.

Courbet and Daubigny Inspire

☙ Another man who influenced the developing Impressionist style was the Realist painter Gustave Courbet (1829–77). Courbet painted landscapes and the lives of the peasants who lived in the village in which he was born. The jury of the 1850 Salon selected his *Burial at Ornans*, depicting a group of about 30 figures amongst whom were a cynical clergy and an ugly, brutish peasantry. It caused a scandal. Courbet, however, was merely presenting a realistic vision of the people with whom he had lived as a child and believed he was being entirely sympathetic in his depiction. His rebelliousness and independent stance was an inspiration to the younger generation of artists, amongst whom was an admiring Claude Monet.

☙ In his correspondence with Boudin, Monet described Charles-François Daubigny (1817–78), another important precursor to Impressionism, as an artist who 'understands nature'. Daubigny was a landscape artist of the Barbizon School, the movement that sought, in the face of the stridently academic nature of French painting at the time, to bring realism to art. Another Barbizon painter was Jean-François Millet (1814–75), whose painting *The Gleaners* shows three women working on the harvest and contains no allegorical message. Nor does it have a historical or mythological context. As such, it was revolutionary and its influence can be seen in Monet's and the Impressionists' championing of the everyday and ordinary in their paintings.

Hints of Impressionism

☙ The next great influence on Monet was the Dutch landscape and seascape artist Johan Barthold Jongkind. Although his work had been accepted by the Salon jury of 1848 and he had been acclaimed by the writers Émile Zola (1840–1902) and Charles Baudelaire (1821–67), he was singularly unsuccessful – a state of affairs exacerbated by alcoholism and bouts of depression.

His work showed hints, however, of the Impressionist style of the future. He worked out of doors and made a constant study of the sun's rays and the reflections created by light travelling across the landscape. In his studies of nature in changing conditions, he anticipated Monet's later painting cycles such as those featuring Rouen Cathedral and the haystacks.

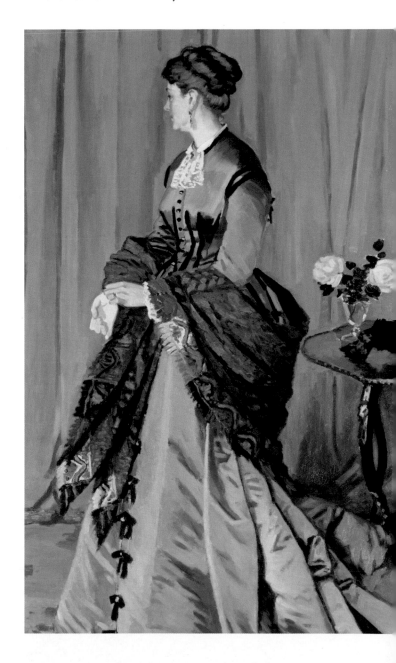

Monet met Jongkind in 1862, while the former was recovering from the typhoid he had contracted during his military service in Algeria. He later described how Jongkind '... added the crowning touch to the encouragement Boudin had already given me. From then on my true master was Jongkind and to him I owe the education of my eye.'

Manet the Master

Of great importance to not only Claude Monet, but also to all the members of the burgeoning, but still unformed, Impressionist movement, was the work of the painter Édouard Manet, one of the first artists to follow the urging of Baudelaire and approach modern-life subjects – subjects of *La Vie Moderne* ('Modern Life').

Manet created a sensation at the Salon des Refusés with his painting *Luncheon on the Grass*, which became a rallying point for all the disgruntled young artists who were constantly being rejected for the Salon by an art establishment terrified of their iconoclastic approach. This painting was not in any way political in its subject matter, but it was highly political in the way that it made an appeal for the freedom of the artist

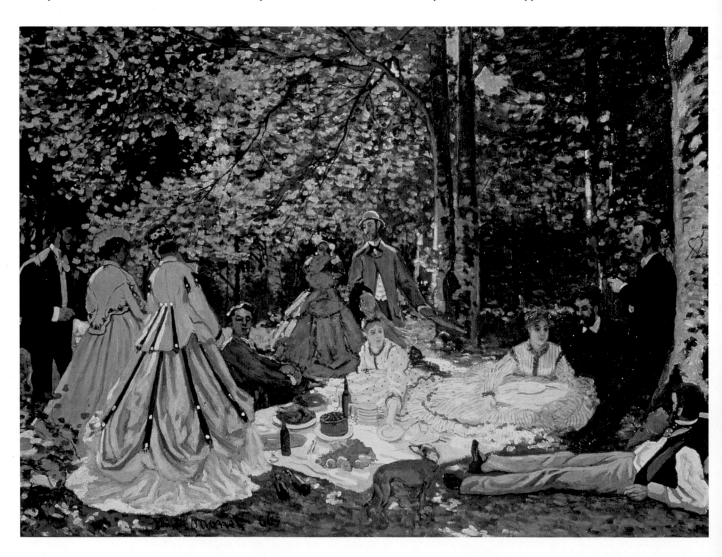

from the stultifying restraints of academic painting. Even the fact that Manet executed the work on a canvas of a size normally reserved for grander subjects was guaranteed to irritate those who made the rules for French art.

~ The painting that Monet successfully submitted to the Salon of 1866 – *The Woman in the Green Dress*, a life-sized portrait of Camille – owed a great deal to Manet, who quipped that Monet was imitating not just his style but also his name. Nonetheless, the two would later become firm friends.

Bazille – A Financial and Artistic Influence

~ Frédéric Bazille, Pierre-Auguste Renoir and Alfred Sisley, who attended Gleyre's classes at the same time as Monet, all came from very different backgrounds but each of them shared the same beliefs about art.

~ Born into a wealthy family in Montpellier, Bazille was seduced into becoming an artist by the painting of Eugène Delacroix. His family, however, would only permit him to study painting on condition that he studied medicine at the same time. He moved to Paris in 1862 and met Sisley and Renoir before he began his studies. In 1864, by which time he was also acquainted with Édouard Manet and Claude Monet, he failed his medical exams and became a full-time painter.

~ Bazille's influence on Monet was often a financial one because, until his tragic death in the Franco-Prussian War in November 1870, it was to him that Monet most often turned for money. After the Salon's rejection of Monet's *Women in the Garden* (*see* above right), Bazille bought the painting from him for 2,500 francs, paying Monet about 50 francs per month for it, as a kind of allowance.

~ The two men were very close. In the early years of their acquaintance, they posed for each other, worked side by side in the open air, helped each other find patrons and planned exhibitions together. Around January 1865, they even shared a studio in Rue de Furstenberg, in Paris.

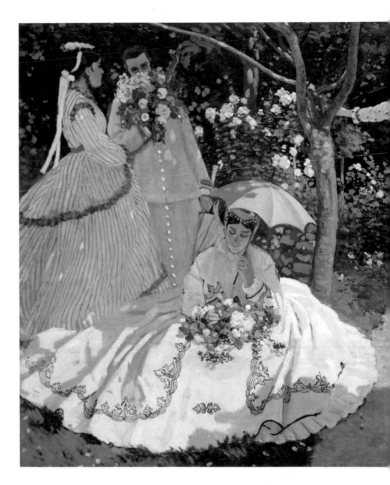

~ It was probably through Bazille that Monet was first introduced to Manet's work. Bazille had embarked on a study of Manet in 1863 and shared his enthusiasm with his friend. When Monet started to paint his *Luncheon on the Grass* (*see* opposite page), Bazille was the painting's main model.

Renoir and the Colour of Shadow

~ Renoir was an altogether different individual from the rest. Born into a working-class family in Limoges, as a child he worked in a porcelain factory painting designs on fine china. He arrived in Paris in 1862, where he began to study at Charles Gleyre's studio. In the late 1860s, he and Monet worked closely together, painting the same scenes – views of resorts like La Grenouillère and busy Parisian street scenes. It could be said that together Monet and Renoir made the important discovery that shadows are not brown

or black, as had been previously believed. Rather, they suggested, shadows reflect the colours of the objects by which they are surrounded. This can be clearly seen in the beautiful *Woman with a Parasol – Madame Monet and her Son* (*see* page 85) in which Camille's shadow falls to the ground in shades of violet and brown.

Sisley in the *Plein Air*

☙ The third of this trio of like-minded friends was Alfred Sisley, a French-born Englishman who spent much of his adult life in France. Son of a wealthy silk merchant, Sisley also met Monet at Gleyre's studio after abandoning a business career in London, but unlike Monet and the others, he would remain a *plein air* landscape artist for the remainder of his life. Sadly, however, he would not remain wealthy, as the Franco-Prussian conflict put paid to his father's business.

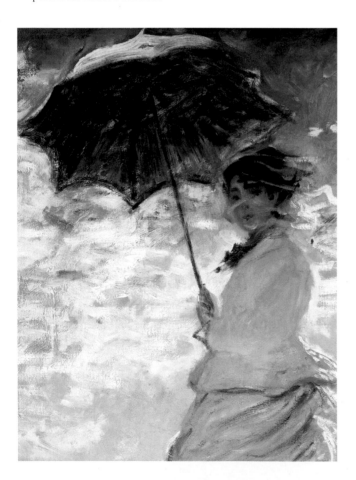

Mutual Influences

☙ Finally, it is worth adding to the list of Monet's influences the English painter J.M.W. Turner (1775–1851) and the American artist James McNeill Whistler (1834–1903). Turner undoubtedly influenced Monet and the Impressionists with his sensitivity to warm colours, the informality of his compositions and his interest in modern reality in paintings such as *Rain, Steam and Speed – The Great Western Railway*. Both Monet and Whistler acknowledged a debt to Turner. Whistler, meanwhile, studied in the studio of Charles Gleyre in Paris a few years before Monet, Renoir, Bazille and Sisley, and like them, he was inspired and influenced by the work of Édouard Manet. Whistler and Monet became close friends during the 1880s but met earlier, and it has long been suggested that Whistler's *Nocturnes*, themselves influenced by the Japanese prints of Hiroshige, were a major inspiration for Monet's 1872 painting *Impression: Sunrise* that gave the Impressionist movement its name.

Patronage

☙ **As well as** Bazille, Cailebotte and Manet who all helped Monet financially, he enjoyed the patronage of a couple of wealthy men – Le Havre ship owner Louis Joachim Gaudibert and Parisian department store magnate Ernest Hoschedé.

A Lifeline

☙ Gaudibert's commission for a portrait of his wife arrived at just the right moment for Monet. Of the many bad years he had, 1868 was one of the very worst. The pictures he sent to the International Maritime Exhibition at Le Havre in the spring were all seized by creditors and in the summer, he, Camille and baby Jean were thrown out of their lodgings at Fécamp for failing to pay their rent. Monet was suicidal when Gaudibert approached him and gave him the commission as well as buying other pictures. Monet had been ready to abandon painting, but was able to carry on with the money Gaudibert paid him.

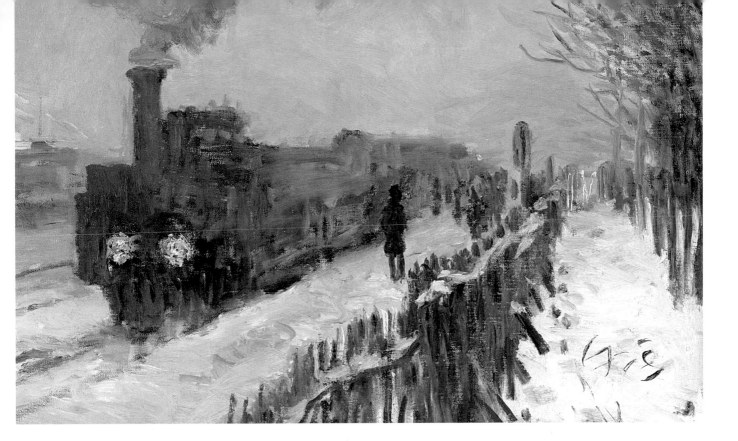

More Than a Patron

Ernest Hoschedé played an even more significant role in Monet's life. In 1876, he commissioned Monet to paint some panels in a drawing room at his residence, the Château de Rottembourg. The money came in handy for the constantly impoverished Monet. A year later, however, Hoschedé was ruined when his business empire collapsed. Bankrupt, he fled to Belgium abandoning his pregnant wife and five children. On his return, he and his family moved in with Monet at Vétheuil. Eventually, however, the Hoschedé marriage foundered and, following Ernest's death in 1891, widow Alice married Monet. When Alice died in 1911, Blanche, the second daughter of Ernest and Alice, became Monet's assistant and companion. She also became an accomplished painter.

The Saviour Dealer

Another man who played a vital role in Monet's career was the art dealer Paul Durand-Ruel, described by Monet himself as 'our saviour'. He represented artists of the Barbizon school, such as Corot, established commercial relationships with a number of Impressionists and mounted the first major exhibition of their work at his London gallery in 1872.

He was introduced to Monet in 1870 by the artist Daubigny in London and immediately bought a number of paintings from Monet for 300 francs each. From that time on Durand-Ruel represented Monet. Importantly, he championed Monet's work, as well as that of the other Impressionists, in New York, organizing an exhibition of 300 paintings at the American Art Association, of which 49 were Monet's. The Americans proved to be very open-minded about Monet and Impressionism. As Durand-Ruel famously quipped, 'The American public does not laugh. It buys!' Indeed, it was American money that helped Monet to buy Giverny, create his garden and enjoy a comfortable lifestyle in the last three decades of his life.

The Salon and Exhibitions

By the middle of the nineteenth century the Salon was the greatest annual art event in the world, the standard against which the work of French artists was measured. Organized originally by

the French government and from 1881 by the Société des Artistes Français, it had begun in 1674 but was not opened to the public until 1725.

Success and Failure at the Salon

- Acceptance by the jury at the Salon was vital to an artist's success and in the early years of Monet's career it was a constant preoccupation and source of disappointment for the artist. When Monet first went to Paris, he visited the Salon, and was no doubt overawed by the thousands of paintings that were hung from floor to ceiling, covering every inch of wall space.

- He enjoyed some early success with the jury's acceptance for the 1865 Salon of his two seascapes, *La Pointe de la Hève* and *L'Embouchure de la Seine à Honfleur*. In 1866, *The Woman in the Green Dress*, featuring Camille as his model, was accepted but he was depressed by the 1867 jury's rejection of *Women in the Garden*.

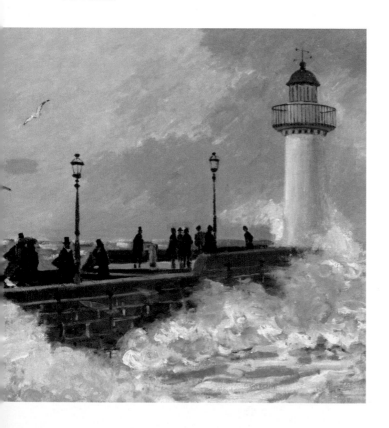

- The 1868 Salon jury accepted another seascape, *The Jetty of Le Havre* (*see* below left), but he was rejected in 1869 and 1870, the latter rejection particularly galling because his friends Renoir, Sisley and Bazille all had paintings accepted. He did not submit again for 10 years, with one picture gaining admission in 1880. It was hung so badly, however, that he never again subjected himself to that particular humiliation.

Founding an Alternative

- Petitions by artists for further Salon des Refusés in 1867 and 1872 were rejected by the Salon. Therefore, in late 1873, Monet, Renoir, Sisley and Pissarro formed the *Société Anonyme Coopérative des Artistes Peintres, Sculpteurs, Graveurs* ('Co-operative and Anonymous Association of Painters, Sculptors and Engravers') as a vehicle for exhibiting their works independently of the Salon. It would soon also include Cézanne, Degas and Berthe Morisot, amongst others. Their first exhibition opened in April 1874 to a mixed reception. Monet and Cézanne were singled out for particularly savage disapproval, with critic Louis Leroy's sarcastic panning of Monet's *Impression: Sunrise* famously giving the movement its name.

- A condition of membership of this group was that they would not submit to the Salon, but as the years passed there were a number of defections by members of the core group. Monet himself defected by submitting to the 1880 Salon and he began to object to some of the artists who were being allowed to exhibit, accusing the *Société* of 'opening doors to first-come daubers'.

Industrialization

- **People were accustomed** to seeing paintings depicting mythological and historical themes, finished to a high technical standard with such a glossy surface that there was no evidence that the colour had been put there by a brush. One can only wonder, therefore, what they thought of the paintings Monet executed at the Gare Saint-Lazare in 1877.

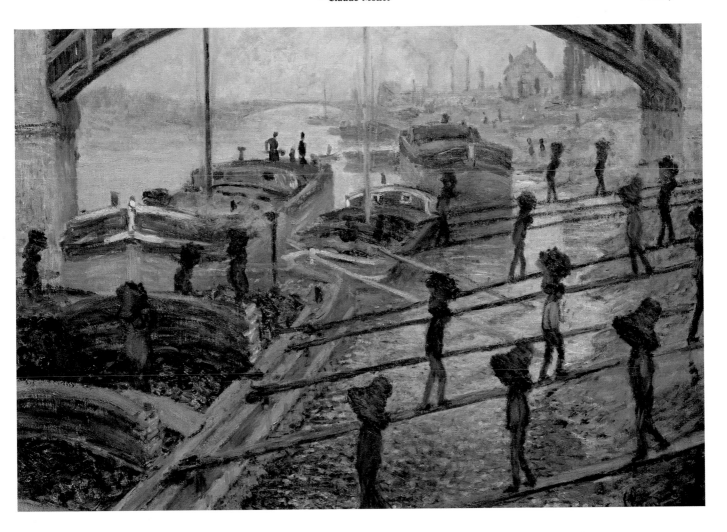

They must have seemed brutish and even unfinished. There were sections of the works where the canvas even showed through, covered only by wispy suggestions of clouds of steam. When Monet showed six of his station paintings at the 1877 Impressionist exhibition, one rich collector is said to have been so horrified that he ran to the door and demanded the return of his admission fee.

Influence of the Railways

The railways were still relatively new in Monet's time and much about them fascinated painters, who sought to depict life in the modern world. Monet was no different. That autumn, he had painted a series of panels at Ernest Hoschedé's château. He moved from painting hunting scenes, ponds, gardens and a flock of white turkeys to painting the bustle, the noise and the dirt of a railway station.

Monet was fascinated by the railways. His house at Argenteuil was close to a railway line and he would later see Giverny for the first time from a train window. He was interested in depicting this new phenomenon with its noise, smoke, iron and glass, and provide something of a commentary on modern society. The station in *The Gare Saint-Lazare* (*see* page 92) is almost cathedral-like and could be said to reflect the new religion created by the nineteenth-century Industrial Revolution – the 'religion' of industry and commerce.

Places

AT THE AGE OF FIVE, MONET MOVED TO LE HAVRE, a busy port on the Normandy coast, where he began a love affair with the sea that would see him hailed as one of the greatest of all seascape painters. As a child, his every spare moment was spent on the beaches around his home.

Normandy

~ **Throughout his career** he would return to the rugged Normandy coast to try to make visual sense of its dramatic cliffs and promontories and of its waters dotted with sailing vessels. This can be seen in the 1862 pastel and gouache *Sunset at Sea* (*see* page 39), in which it is immediately evident that Monet's interest lay not in the boats – represented as indistinct blobs of black paint – but in the sky made up of broad swathes of various colours, dark in the foreground but becoming lighter as the eye is led to the orange-red horizon.

Capturing the Coast

~ *The Jetty of le Havre*, accepted by the jury of the 1868 Salon, depicts the pier at Le Havre with a raging sea battering against its sides and angry foam spilling over on to people braving the elements. A rainbow cuts through dark clouds that rise up from the horizon, presaging better weather. It is only one of a number of paintings of Le Havre, the most famous of which is probably *Impression: Sunrise*, the picture of the harbour at the port after which the Impressionist movement was named.

~ Between 1880 and 1886, Monet used the English Channel coast as a major motif in his work, and studying the sea seems to have revived his spirits following the death of Camille in 1911. These works are amongst the greatest achievements in marine painting.

~ From 1881 to 1882, he concentrated on the dramatic rocks and cliffs between Varengeville and Dieppe. His brush intricately explored each ravine and rock, and the paintings on occasion become almost abstract – divided into the three sections of sky, sea and cliff. Brushstrokes are animated and contrasting colours sit next to each other, lending these works vigour and drama.

~ Sometimes, however, he brought a sketch-like informality to the work, as in the 1883 *Boats on the Beach at Etretat* (*see* right), in which colourful boats line the beach with roughly executed cliffs and rocks in the distance.

~ Monet did plan, later in life, to return to all these places and once again paint the motifs that had meant so much to him earlier in his career, but it was a plan that was never fulfilled.

Paris

~ 'It's no good persevering in isolation,' Monet once said, 'unless of course one is supremely gifted, and even then you cannot expect to invent an art all by yourself, in a country

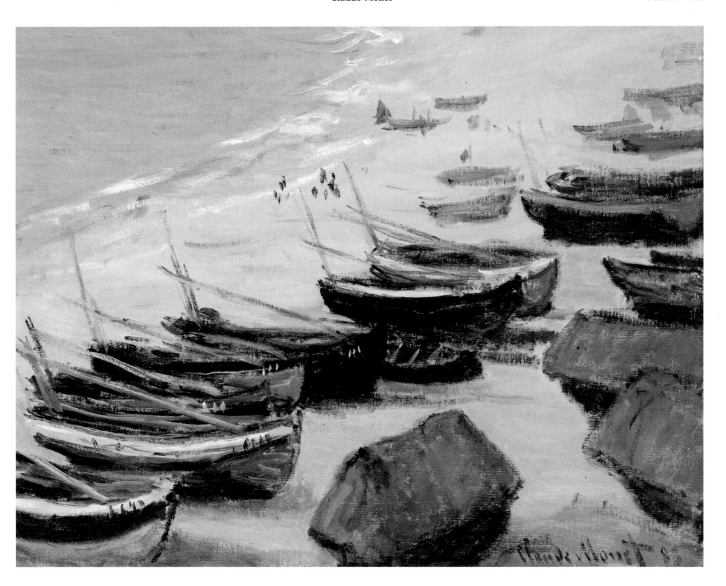

town, cut off from criticism and points of comparison, with nothing but your own instinct to guide you.'

As he quite correctly surmised, to make it in the world of art in the middle of the nineteenth century in France, an aspiring artist had to go to Paris. Firstly, it was necessary to see what other artists were doing, both to learn from them and to understand the directions in which art was heading. The young artist would, therefore, visit galleries and studios, and would ensure that his itinerary also included a visit to the Salon: the exhibition that could launch a new young artist's career, gaining reviews in the press and attracting collectors and art lovers. Study provided another good reason to go to Paris. There were countless teachers and academies, where a good grounding in the basics could be achieved and, as we have seen from Monet's experience, there were ample opportunities to make friends with artists who shared similar artistic goals. Another very good reason to travel to Paris was the fact that dealers and collectors were more likely to find your work there and you them than in an artistic backwater like Le Havre.

studio, where the Impressionist group began to form. He remained in Paris, suffering the highs and lows of Salon acceptance and rejection, until the outbreak of the Franco-Prussian war in 1870, when he fled to London to avoid being called up.

Living Outside the City

꙳ From that time on, Monet lived in small towns and villages on the outskirts of, or not far from the capital – places such as Argenteuil, Vétheuil, Poissy and Giverny. They were all close to the River Seine from which Monet derived so much pleasure and inspiration. He painted it and the life that went on around it many times, in works such as *Seine at Asnières* (*see* page 74), *Small Branch of the Seine* (*see* page 95) and *The Seine at Port-Villez* (*see* page 109).

꙳ The areas where he lived were often represented in his work. Of all of the places he lived before Giverny, he was probably happiest at Argenteuil, where he and Camille lived for a number of years and where they would regularly welcome the other members of the Impressionist group. With Renoir, he painted a number of riverscapes there in the autumn of 1872. Paintings from this period include the charmingly informal *The Luncheon: Monet's Garden at Argenteuil*, in which Camille takes a stroll in the garden with a friend after lunch while Jean plays on the ground near the table.

꙳ The usual money problems plagued Monet towards the end of his time at Argenteuil, and in 1877 he and his family were forced to move to Vétheuil, another small town on the Seine near Paris. This is the place which Monet shared with the Hoschedés and where Camille died in 1879, which resulted in an unhappy household despite beautiful works such as *The Artist's Garden at Vétheuil* (*see* page 78), painted in 1880.

꙳ Monet and Alice tried living in Poissy and Pourville, but it was only when they discovered their paradise at Giverny in 1883 that the Monet family at last discovered true domestic contentment.

First Parisian Encounter

꙳ Monet's first trip to Paris in May 1859 took in the Salon, where he admired the work of the Barbizon painters Daubigny and Troyon. At the Académie Suisse, he met Camille Pissarro and he spent his spare time at the Brasserie des Martyrs, where the Realist group gathered to argue about art, under the watchful eye of their leading light, Gustave Courbet.

꙳ He also first encountered the work of Delacroix during this time, marvelling at his use of colour and depiction of light, but his stay was curtailed by his military call-up. Returning to the capital in 1862, Monet began to study at Gleyre's

London

- **'Without fog,'** Monet once said, 'London would not be a beautiful city.' Undoubtedly, London, with its hazy atmosphere and constantly changing conditions due to the smoke belching from its countless factory chimneys, was made for Monet; this is shown in the fact that he made four visits to the British capital – in 1870, 1899, 1900 and 1901. During these trips he revelled in the light and atmosphere of the foggy city.

A Fortuitous Trip

- His first visit, in September 1870, was, as we have seen, forced upon him by the outbreak of the Franco-Prussian war. It must have seemed like a very good decision when he learned that his friend and benefactor Frédéric Bazille had been killed in battle. The decision must have seemed even better when he was introduced to the art dealer Durand-Ruel, who would have a transformative effect on his life and career.

London Subjects

- It is his later visits that provide his most interesting depictions of London. Painting from his fifth-floor room at the Savoy Hotel, Monet had two vistas to paint. Looking to the left he produced works such as *Waterloo Bridge* (*see* page 128) and turning his canvas to face the other direction, he surveyed a scene divided by the Charing Cross Bridge with the majestic neo-Gothic forms of the Houses of Parliament rising behind it, as seen in his *Charing Cross Bridge, The Thames* (*see* page 127).

- He also painted a series of views of the Palace of Westminster, all from the same viewpoint: a window in St Thomas's Hospital overlooking the Thames. As ever, they were painted in different conditions and at various times of day. He had by this time abandoned the practice of finishing his paintings *in situ* and took these works unfinished back to France with him.

- An example of these works, *Parliament at Sunset* (*see* page 131), provides an extraordinary, almost Expressionist view of the Palace of Westminster, with the sun touching the edges of the clouds above its towers with an orange glow, reflected brilliantly in the subtly executed waters of the Thames below.

- The Parliament series proved extremely difficult to execute. The atmospheric conditions changed so rapidly that Monet was forced on occasion to hurriedly search through the hundred canvases that he had begun in order to find the one most closely approximating what was happening in front of him.

Holland

- **Monet visited Amsterdam** twice – in 1871, on his way back to France from London, and in 1874. Although delighted by the atmospheric conditions – clouds and grey light – he was disappointed with the work he produced there and the Dutch paintings, such as *The Windmill, Amsterdam* of 1871 (*see* page 65) and his 1874 oil *Canal in Amsterdam* (*see* page 79), are not amongst his best-known work.

Discovering Japanese Art

- His stay in Holland was important for one particular reason, however. One day he went into a shop to buy food and noticed that the owner was using Japanese prints to wrap his produce.

Struck by the beauty of the illustrations and the unusual nature of their composition, Monet immediately bought some and took them home with him. It marked the start of a lifelong obsession with Japanese prints and Japanese art that influenced not only his work, but also that of many of the other Impressionists. He put together a fine collection that included work by acknowledged masters of the form such as Hiroshige, Hokusai and Utamaro.

இ Five years after his discovery, he painted *La Japonaise* (*see* page 90), showing Camille in a blonde wig and a striking, heavily embroidered Japanese costume, which bears a painted head of an angry samurai that seems to actually be emerging

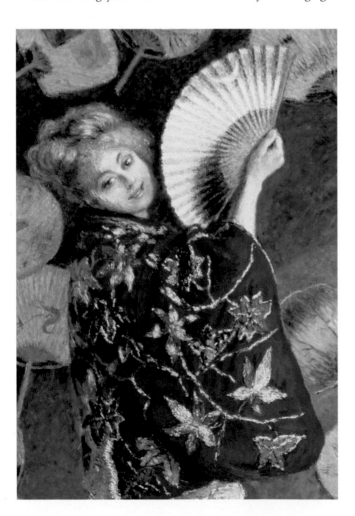

from the cloth. It is a decidedly un-Impressionistic depiction, apart from Camille's face, which could almost have been painted by Renoir. It was a success. Monet sold it for 2,000 francs but in 1918 it was sold again for 150,000 francs.

Giverny

இ **Rarely can place** and art have come together so perfectly as at the last of Monet's many residences – the beautiful Giverny.

இ Giverny sat between the valley of the Seine and hills blanketed with vineyards and orchards. The large farmhouse was situated in two acres of garden, a rambling building with pink walls and a slate roof. It was book-ended by two barns and in the grounds was a wonderful walled country garden. There was a railway line at the bottom of the garden, on the other side of which was the small River Ru that ran into the Epte that in turn flowed into the Seine. The light was perfect and constantly changing, just as Monet liked it. He was delighted and wrote to Durand-Ruel, 'Once settled, I hope to produce masterpieces because I like the countryside very much.'

Constant Change

இ He converted one of the barns into a studio and planted a vegetable garden and a flower garden, the latter to provide subjects for still-life paintings when bad weather prevented him from going out into the countryside in search of motifs. He worked on the garden at Giverny over the next four decades, adding land to it and creating the famous lily pond, the depiction of which was to occupy the last years of his life.

Venice

இ **If London**, with its smoggy atmosphere, was made for Monet, then it is difficult to know just how perfect he must have felt Venice was – a city that united his obsessions: water, magnificent buildings and spectacular light.

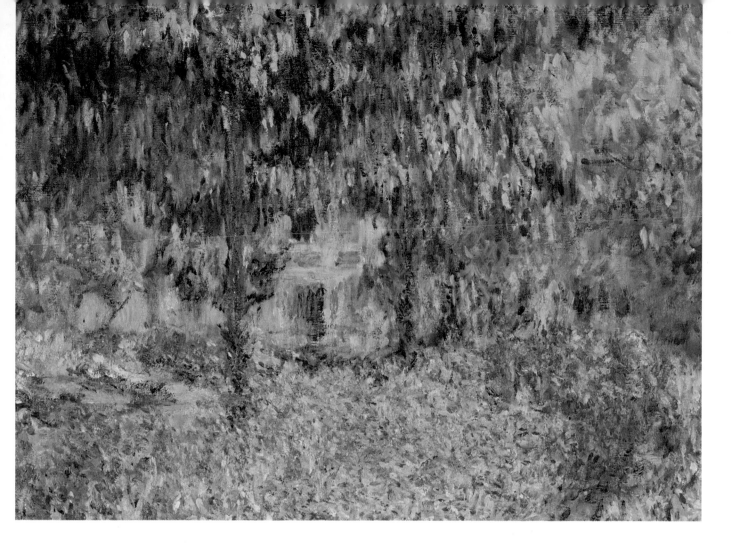

In 1908, he and Alice were invited to visit Venice, an invitation that seems to have arrived at just the right time for the 68-year-old artist who had been in poor health and was unhappy with the work he had been producing. He accepted the invitation, therefore, in the hope that the trip would revive his enthusiasm for his work and for life. During this visit, he would paint relatively few canvases – 37 – but they would become some of his best-known and best-loved work. Characteristically, however, Monet was most taken by what he described as its 'unique light' – 'It is too beautiful to paint!' he exclaimed when he first arrived. 'It is untranslatable!'

Venetian Subjects

He and Alice stayed at the Grand Hotel Britannia, from whose landing stage could be enjoyed spectacular views of the distant island of San Giorgio. He set up his easel there and began work on a series of views of the island in the distance. Amongst other works he painted in Venice were *Le Palais Contarini* (*see* page 34) and several versions of *The Doge's Palace in Venice* (*see* page 133). He described them as 'trials and beginnings' but they were finished afterwards back in his studio at Giverny. 'It is so beautiful,' he wrote to the art critic Gustave Geffroy. 'I console myself with the thought of returning next year, for I have only been able to make attempts, beginnings. But how unfortunate not to have come here when I was younger, when I was full of audacity.'

Sadly, however, Monet never did return to Venice, but when 29 of the Venice canvases were exhibited at the Bernheim-Jeune gallery in Paris four years after the trip, they were a huge critical and popular success.

Styles & Techniques

AT THE VERY BEGINNING OF HIS CAREER, Monet underwent a defining change in style and direction. As a young boy, he had exhibited considerable talent as a draughtsman, with his earliest known works being wicked caricatures. These drawings revealed the artist's inherent artistic ability, his sense of humour and indicated a subversive side to the man who would later defy artistic conventions and lead a new generation of artists. Shortly after making the decision to leave school, Monet left precise and linear draughtsmanship behind him, and began to paint (and draw in charcoal) landscapes. Early landscapes such as these show a lyrical use of colour and the artist's interest in light effects, something that would preoccupy his work for the rest of his life.

En Plein Air

~ 'The first impression is the right one,' landscape artist Eugène Boudin told the young Claude Monet. 'Be just as stubborn as you can in sticking to it Whatever is painted directly, on the spot, always has a vigour, a power, a vivacity of touch that can't be recovered in the studio Three brushstrokes from nature are worth more than two days' work at the easel.'

~ Boudin was a fervent advocate of painting out of doors and he tried to transmit his enthusiasm to the initially sceptical Monet. One of the problems was that Monet did not care for the older painter's work: '...maritime scenes that I found, along with most of the inhabitants of Le Havre, revolting Boudin's sincere little compositions with his correctly delineated little figures, his pleasant boats, his ever so perfect skies and water, drawn and painted only from nature, held no artistic value for me.'

A Sceptic No Longer

~ Painting *en plein air* was, however, a revelation to Monet. 'Suddenly, it was as though a veil had been ripped from my eyes,' he later said. 'I saw what painting could be! From that moment on, my way was clear, my destiny decreed. I would be a painter, no matter what.' When asked once where his studio was, he replied, 'My studio! But I have never had a studio.' Indicating the surrounding countryside with a sweep of his hand, he continued, 'That is my studio.'

Becoming Practical

~ Although artists had always painted in the open air – mostly, as in the case of the English painter John Constable, preparatory sketches for work to be completed later in the studio – it was in the nineteenth century that the practice really took off. A couple of developments helped to make it popular. Firstly, there was the invention by American portrait painter John Goffe Rand (1801–73) of the collapsible metal tube for holding oil paints, replacing the pig's bladders that had previously been used and that often proved unsatisfactory, the paint quickly hardening on exposure to the air. The second innovation was

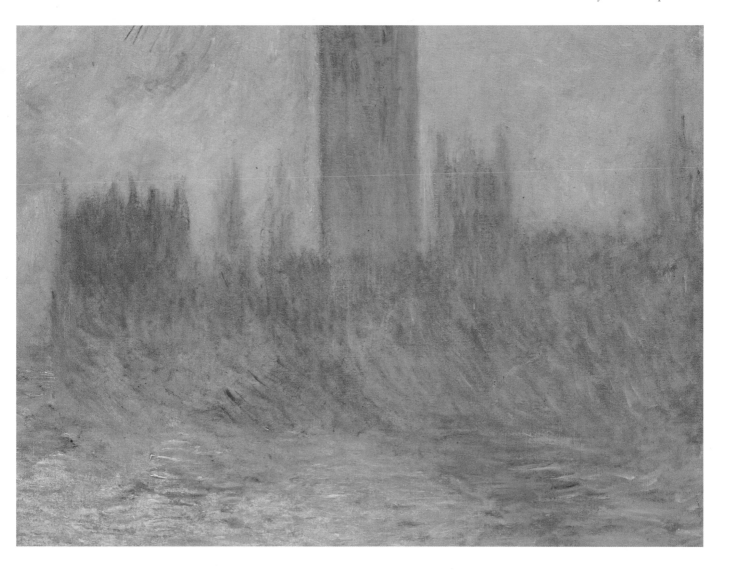

the invention of the box easel – a highly portable contraption with telescopic legs and a built-in paint-box or palette.

Monet's First Outing

Monet's earliest attempt at painting *en plein air* took place in 1858 at Rouelles, near Le Havre, where he painted a view of a stream flowing through verdant countryside with the figure of a woman at the water's edge in the foreground. It is an understandably cautious first attempt, lacking the verve and boldness of the work he would create in the future, but it was a moment that would transform the nature of art for the next century.

A Mixture of Techniques

Later in his career, the very complexity of the work he was producing and the effects he was attempting to capture led to him finishing paintings in the studio. The revelation that Monet did not finish his pictures in front of the motif, as had always been believed, was greeted with surprise in the art world and Monet was irritated by it. He commented, 'Whether my cathedral views, or my London views … are painted from life or not is nobody's business, and is of no importance …. It's the result that counts.'

The Floating Studio

There is a charming 1874 painting by Édouard Manet of Monet working on his studio boat on the Seine at Gennevilliers, where Manet's family home was located, with Camille seated close to him under an awning stretched across the back of the boat. While living at Argenteuil, Monet had purchased a small barge and on it he built a blue-green cabin that helped to turn it into a floating studio. He was no doubt following the example of his friend Daubigny who used his boat Botin as a studio, from which he painted views of the Seine and Oise, often in the area around Auvers-sur-Oise, in the northwest suburbs of Paris.

Monet was helped in the building of the boat by one of his neighbours, the painter Gustave Caillebotte, who happened also to be a marine engineer. The two became firm friends, with Cailebotte even helping Monet financially by buying pictures from him.

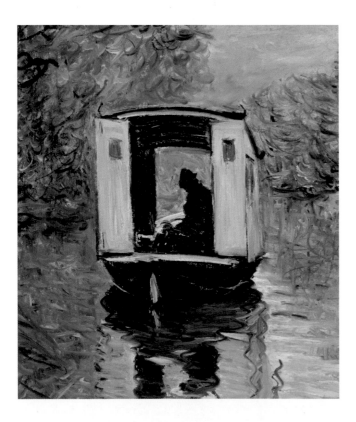

Getting Close to Nature

Monet used his floating studio to paint many scenes along the River Seine, leading Manet to dub him 'the Raphael of the water'. Indeed, water had always held a fascination for Monet, first on the Normandy coast and then on the Seine around Paris. Depicting the constantly changing nature of water presented for him one of the greatest challenges and, when painted in conjunction with the foliage associated with it, it became even more demanding, as he wrote to the critic Geffroy in 1890 when he began to paint the water lilies in his garden: 'I have once again taken up things that are impossible to do – water with grasses that undulate below the surface.'

One series of paintings on which he used the boat to good effect was the one he painted in 1891 of a stand of poplars situated in a marsh along the banks of the Epte, a few kilometres from Giverny. Stationed on the water, Monet painted the poplars around 20 times, from various vantage points on the river and in ever-changing atmospheric conditions.

Series Paintings

By the 1880s, many of the Impressionists had begun to move away from a strict Impressionist style and were exploring other modes of painting. Camille Pissarro began to flirt with Neo-Impressionism, for example, while Renoir travelled to Italy where, influenced by the art of the Renaissance, he began to work in a more Classical style.

As for Monet, he now seemed to be painting not so much the object in front of him, the motif, but rather the air around the subject of his painting itself, what he termed the '*enveloppe*': the atmosphere that lay between him and his subject. It was a less spontaneous approach than the one he took when he was younger and painting quickly *en plein air*. This approach saw him working slowly and deliberately with a great deal of the hard work being done later in the studio, sometimes over a period of years. 'The further I go,' he wrote, '…the better I see that it takes a great deal of work to succeed in rendering what I want to render: "instantaneity",

above all the *enveloppe*, the same light spread over everything, and I'm more than ever disgusted at things that come easily, at the first attempt.'

Much of Monet's work after 1890 falls into series, groups of paintings of the same motif, using repetition to demonstrate the differences in the perception of light at different times of day and in various weather, atmospheric and seasonal conditions.

The Station Series

He had already worked in series, of course, such as in 1876–77 when he produced a number of canvases depicting the Gare Saint-Lazare in Paris, seven of which appeared at the third Impressionist exhibition in April 1877. Compared to the later series, featuring haystacks and Rouen Cathedral, the Gare Saint-Lazare works are more narrative, evoking the drama of the station, as in the thickly impastoed *The Gare Saint-Lazare*, which evokes the noise, smells, soot, smoke and bustle of the new phenomenon of the railways. The Gare Saint-Lazare works present the station in a variety of ways, using a number of

different compositions. Monet is more interested in the diversity of the scenes around the various parts of the station than in the unifying elements of the series, unlike his later cycles.

The Series Process

In 1890, Monet worked on a series of views of poppy fields and in 1891 started on a series of paintings of haystacks that he found in a field near his house in Giverny. He is said to have been walking with his stepdaughter Blanche one day when he was entranced by a haystack that, caught in the bright sunlight, glowed almost white. He hurried home to fetch his equipment but on his return, the haystack's appearance had already altered. 'When I began,' he later said, 'I was like the others; I believed that two canvases, one for grey and one for sunny weather, would be enough.' It was not enough and he sent Blanche back to the house for a canvas and after a while sent her for another, until she wheeled a pile of them to him in a wheelbarrow. He would paint until the effect changed, returning to a previous canvas on which he had started to paint the same effect that was now happening in front of him. To critic Gustave Geffroy he wrote of the process as a 'continual torture ...

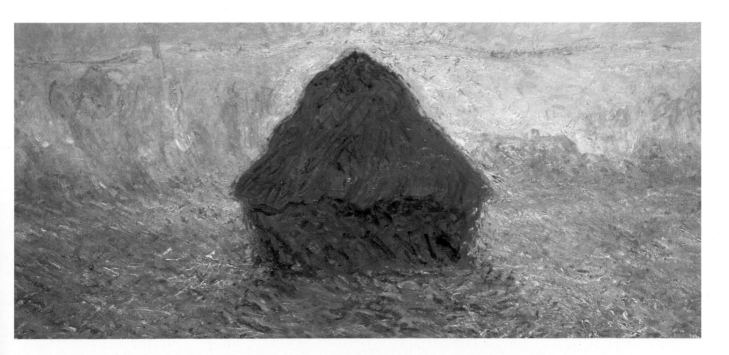

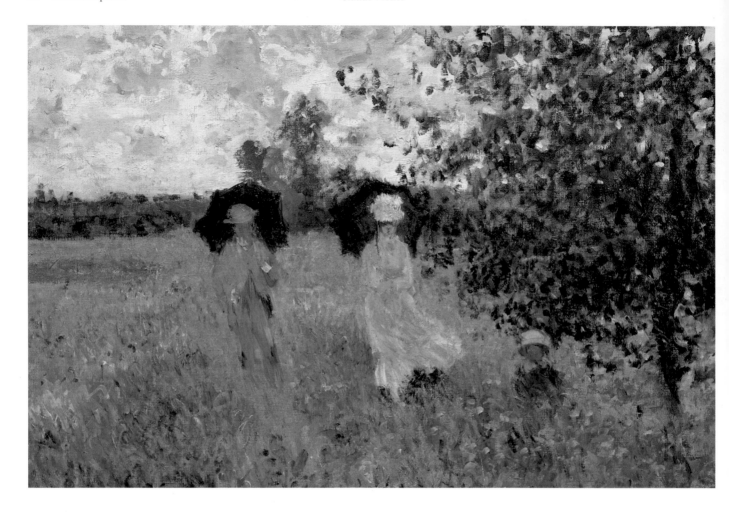

enough to drive one raging mad ...'. However, he persevered and painted haystacks from the end of summer 1890 through to the following spring.

Frustration at the Fleeting

⁓ *Haystacks, Hazy Sunshine* (*see* page 119) perfectly demonstrates Monet's efforts to capture one moment of splendour amongst many. The haystack and the field in which it stands are bathed in a watery, golden light that we know is all too transient. A few minutes after capturing this moment, Monet would have been working on another. The reaction to the haystacks when they were displayed at Durand-Ruel's gallery was ecstatic. Geffroy described him as a 'pantheist poet' and the Russian abstract painter Wassily Kandinsky (1866–1944)

seeing one of the paintings in Moscow four years later, was enthralled by the 'unsuspected power, previously hidden from me, of the palette, which surpassed all my dreams'.

Rouen Cathedral Series

⁓ Between 1892 and 1894, Monet rented space across the street from Rouen Cathedral and created one of his most renowned sets of pictures: 30 depictions of this ancient structure's façade, painted in a variety of conditions. It was a hugely challenging project, and one which gave him nightmares in which the cathedral in various colours was falling on top of him. He wrote of his frustration at one point, 'Things don't advance very steadily, primarily because each day I discover something I hadn't seen the day before In the end, I am trying to do the impossible.'

∼ Monet argued once and for all in this series that colour, as we perceive it, lies not in the materials of a structure but in atmosphere and constantly changing light. But there were those who failed to understand. Neo-Impressionist Paul Signac (1863–1935) wrote that there was 'not enough sky around, not enough ground ...' and described the paintings as 'marvellously executed walls'.

∼ The full power of the Rouen Cathedral series can be seen in *Rouen Cathedral Façade and Tour d'Albane, Morning Effect* (*see* page 122), in which Monet captures the changing effects of light on the sculptures and tracery, with misty, shimmering yellow light illuminating the upper reaches of the tower.

Creating His Masterpieces

∼ In 1890, Monet had bought a parcel of land that lay across the road from his flower garden. He installed a shallow pond that was later increased in size and planted weeping willows, irises and bamboo beside it. In it he planted several varieties of lilies. He told Geffroy, 'I planted my water lilies for fun, when I saw all of a sudden that my pond had become enchanted. I seized my palette. Since then I have had no other model.'

Deteriorating Health

∼ Painting the large panels of water lilies was a mammoth task and Monet, now in his sixties, was no longer the fit young man who had once clambered across rocks on the Normandy coast to gain the best aspect for a painting. He was suffering from occasional dizziness and was often a victim of debilitating depression. More worryingly, the eyes that had served him so well over the years were beginning to trouble him.

Impact of Failing Eyesight

∼ In his 1899 painting of the *Japanese Bridge at Giverny*, Monet calmly evokes this charming spot in his garden, his paint laid on in short brushstrokes as was his habit in his later years. His eyesight, however, was failing and the painting is not as assured as earlier work, although his perceptive use of colour is still intact.

∼ In the last years of his life his eyes were failing him badly and his 1923 *Japanese Bridge at Giverny* (*see* page 141) is an altogether different type of painting that has an almost abstract quality – a frenzy of red brushstrokes, heavy with paint, delineating the bridge and the surrounding flora and fauna. It is evident that he was suffering at this point from a growing inability to control line and colour. It could be also argued, of course, that this was Monet taking his experimentation as far as it would go, applying colour to a canvas with little or no concern for form.

Water Lilies Legacy

∼ The water lilies series of around 250 paintings, the main focus of Monet's work for the last three decades of his life, represent the crowning glory of his series paintings and, arguably, of his entire painting career. Now immensely valuable, one of them – *Water Lily Pond* – was auctioned for almost £41 million in 2008.

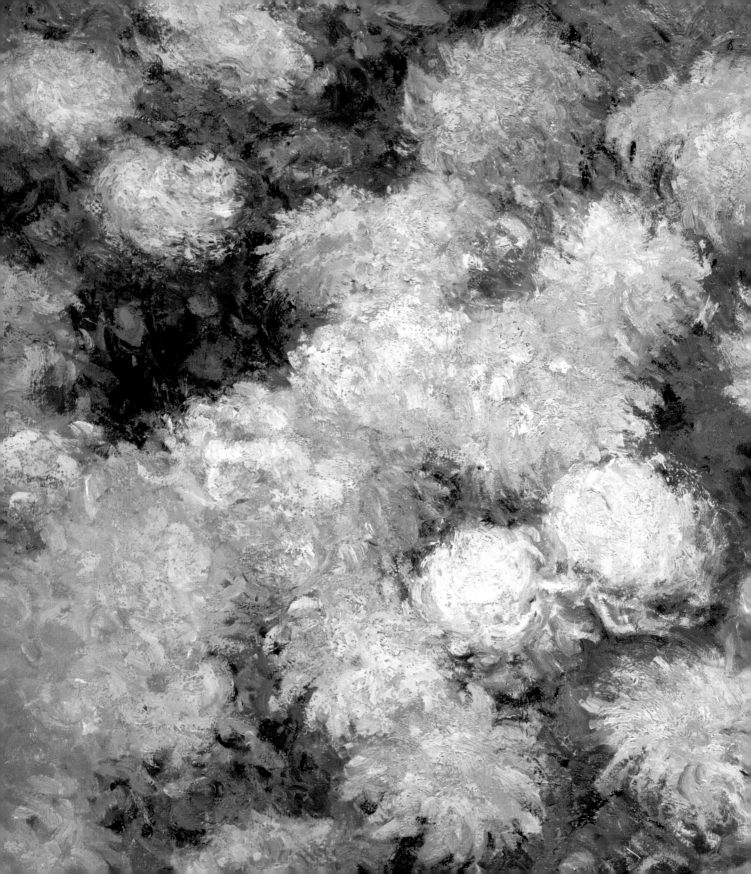

The Masterpieces

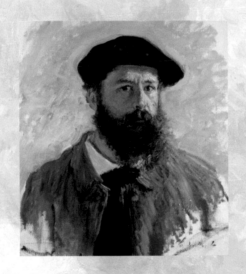

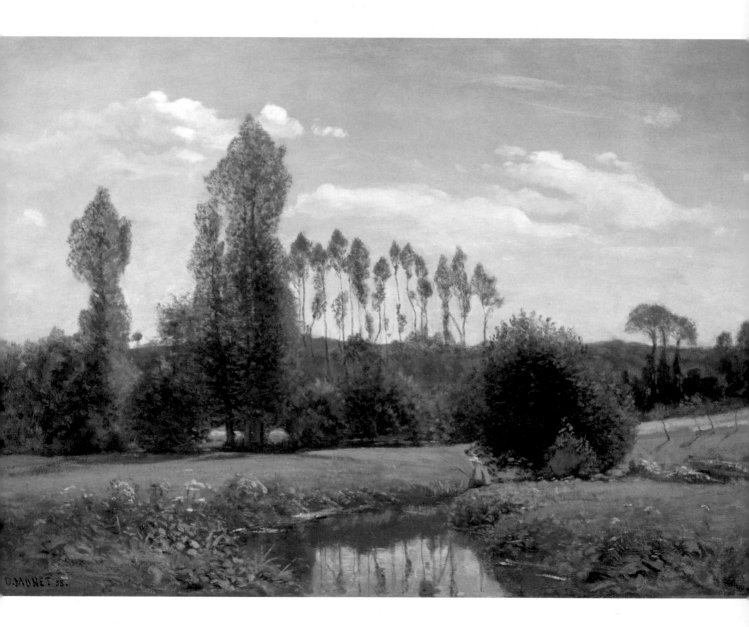

***View at Rouelles*, 1858**
© Private Collection/Noortman Master Paintings, Amsterdam/The Bridgeman Art Library
Medium: Oil on canvas

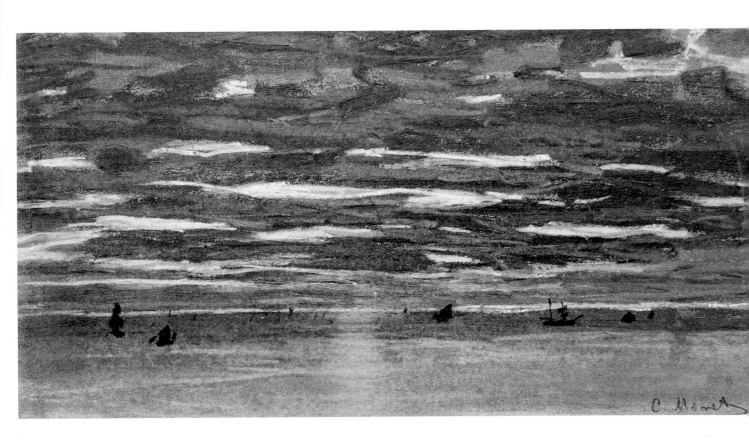

***Sunset at Sea**, c. 1862–64*
© Ashmolean Museum, University of Oxford, UK/The Bridgeman Art Library
Medium: Pastel and gouache on paper

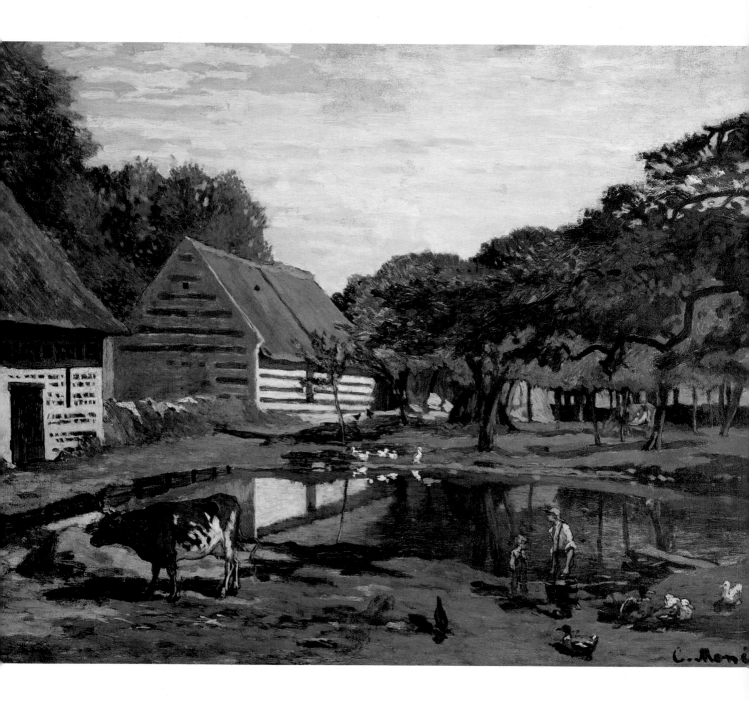

A Farmyard in Normandy, c. 1863
© Musée d'Orsay, Paris, France/Giraudon/The Bridgeman Art Library
Medium: Oil on canvas

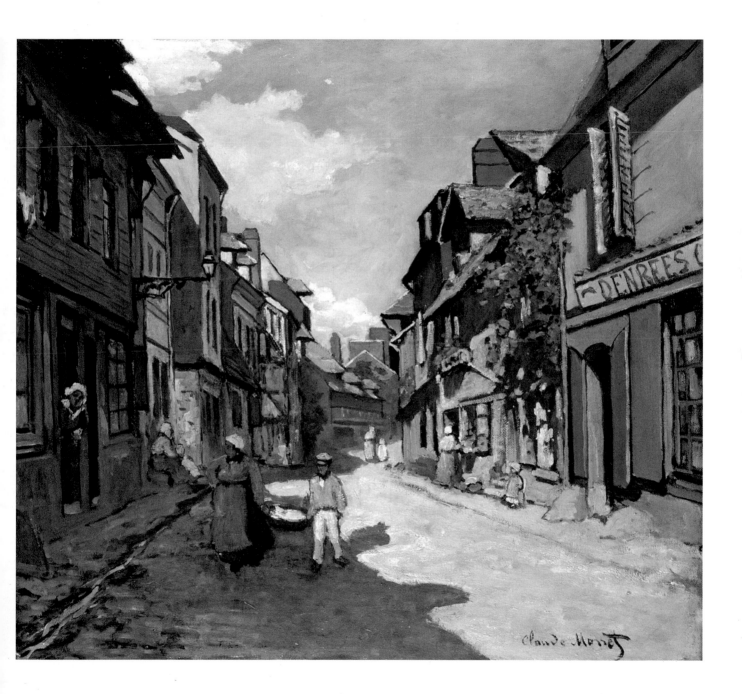

Rue de la Bavolle, Honfleur, 1864
© Kunsthalle, Mannheim, Germany/Interfoto/The Bridgeman Art Library
Medium: Oil on canvas

(Next page) *La Pointe de la Hève*, 1864
© Private Collection/The Bridgeman Art Library
Medium: Oil on canvas

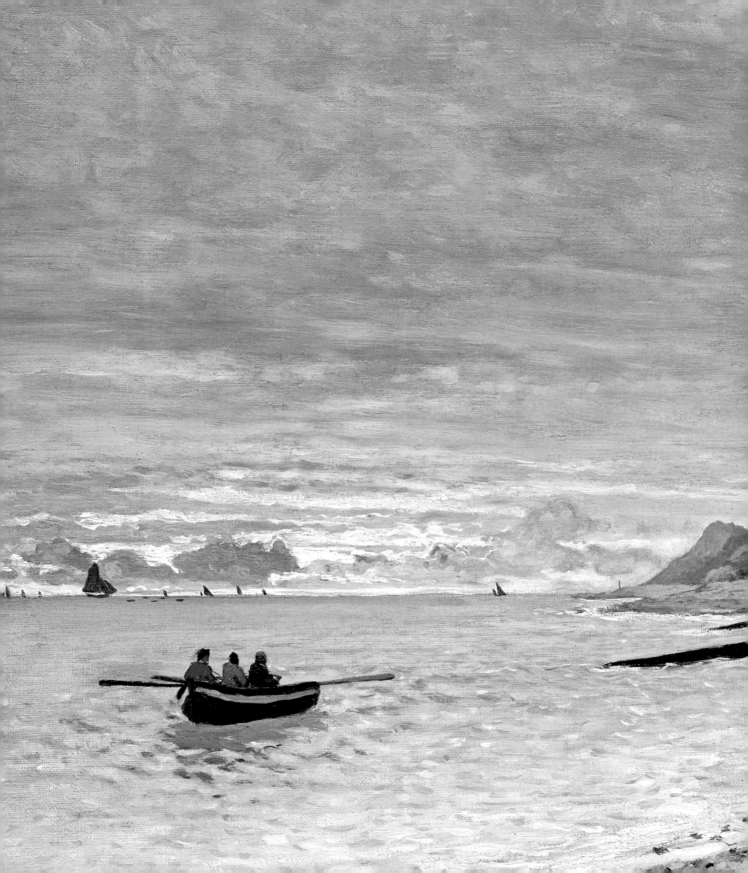

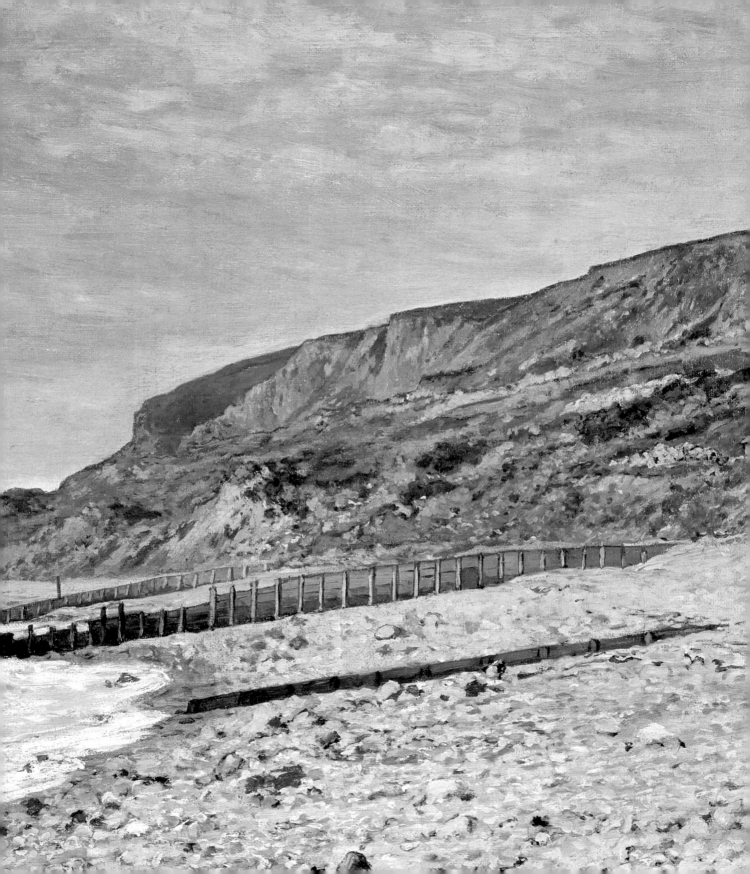

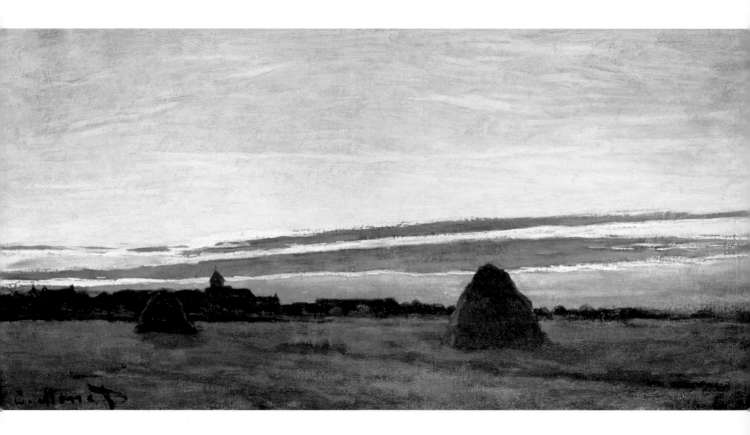

Haystacks at Chailly, 1865
© San Diego Museum of Fine Art, San Diego, USA/The Bridgeman Art Library
Medium: Oil on canvas

The Promenaders, or Bazille and Camille, 1865
© National Gallery of Art, Washington DC, USA/The Bridgeman Art Library
Medium: Oil on canvas

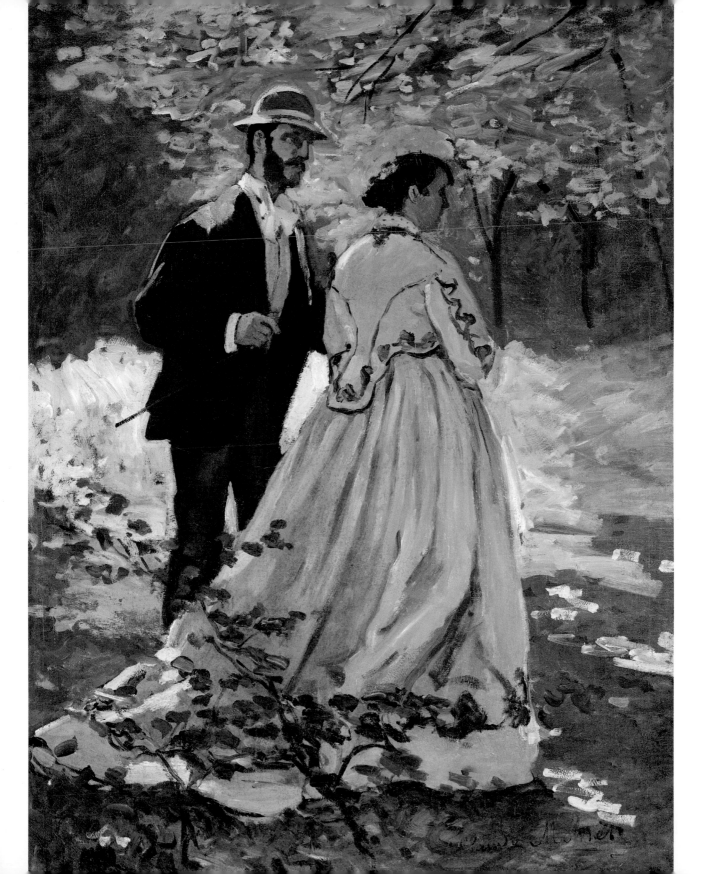

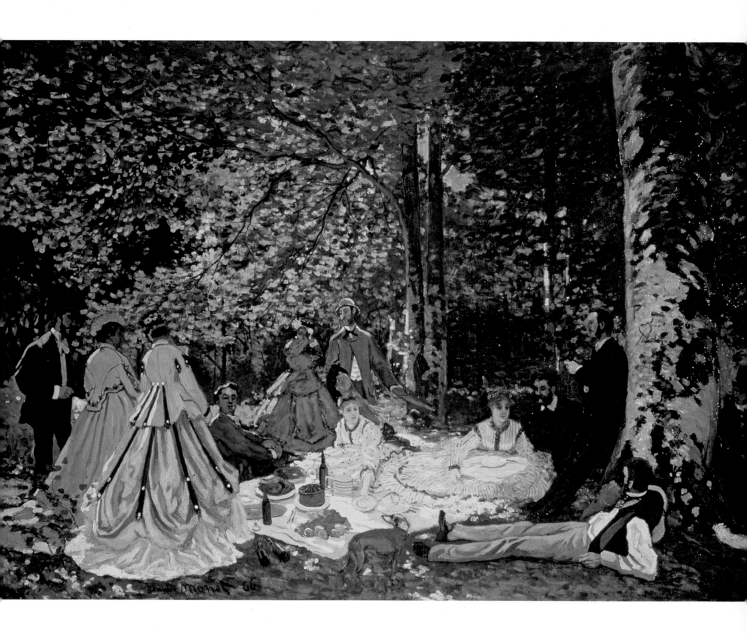

Luncheon on the Grass, 1865–66
© Pushkin Museum, Moscow, Russia/The Bridgeman Art Library
Medium: Oil on canvas

Camille Monet in a Red Cape, 1866
© Buhrle Collection, Zurich, Switzerland/Giraudon/The Bridgeman Art Library
Medium: Oil on canvas

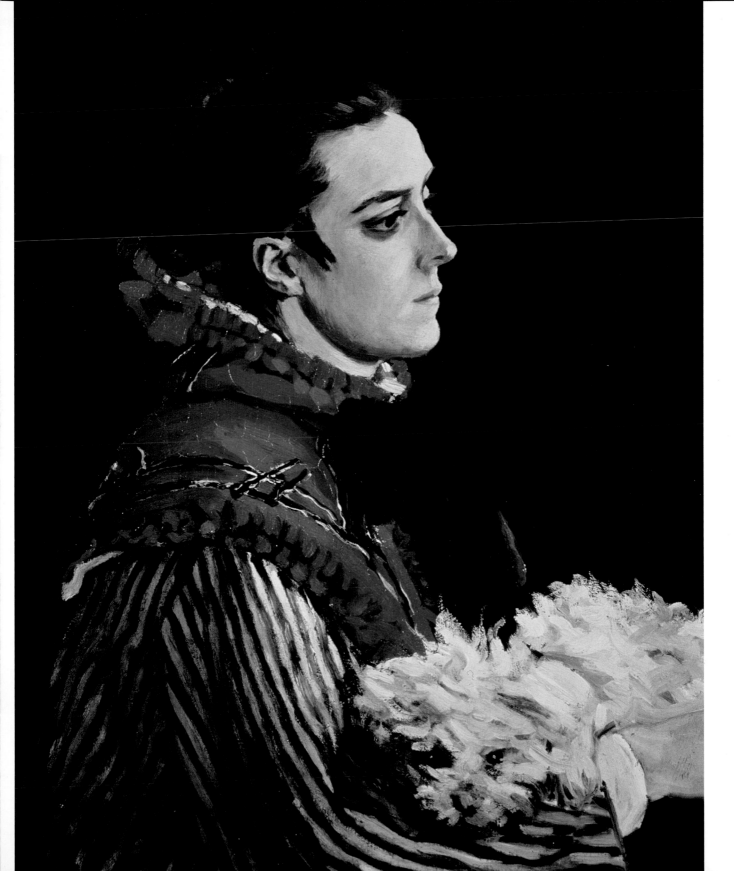

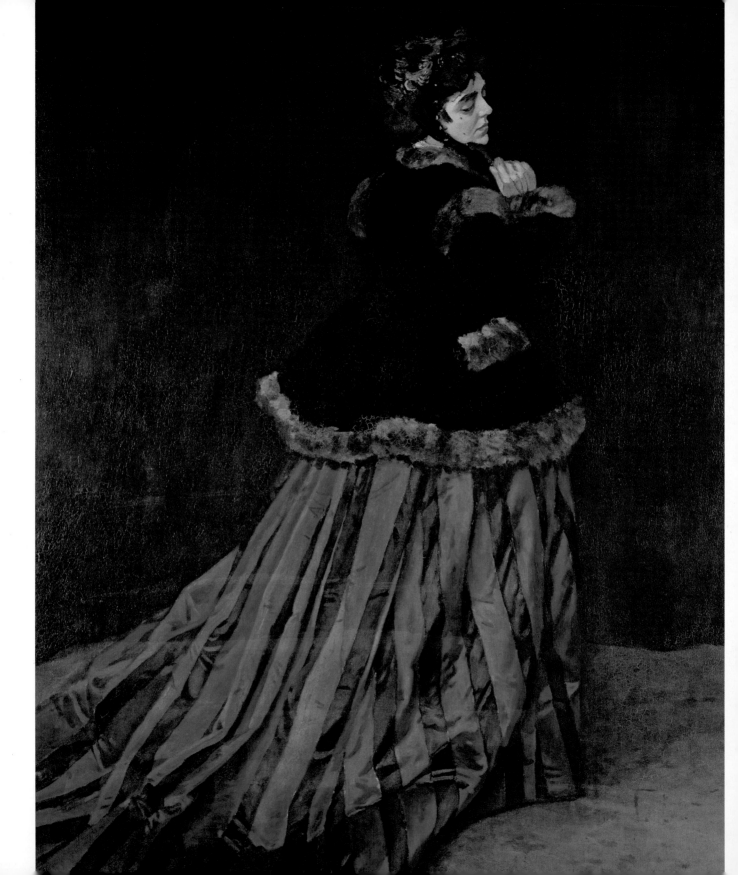

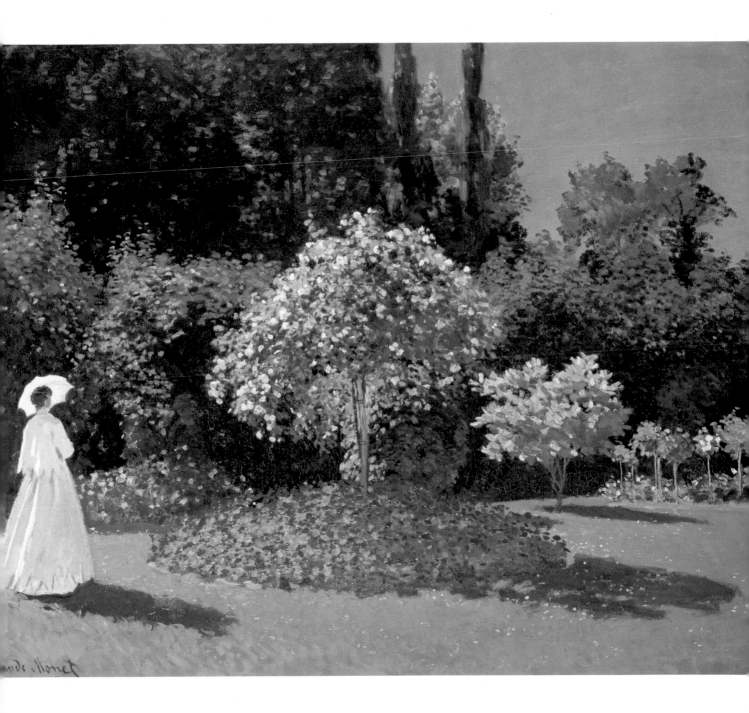

Camille or **The Woman in the Green Dress, 1866**
© Kunsthalle, Bremen, Germany/Giraudon/The Bridgeman Art Library
Medium: Oil on canvas

Jeanne-Marguerite Lecadre in the Garden, 1867
© Hermitage, St Petersburg, Russia/The Bridgeman Art Library
Medium: Oil on canvas

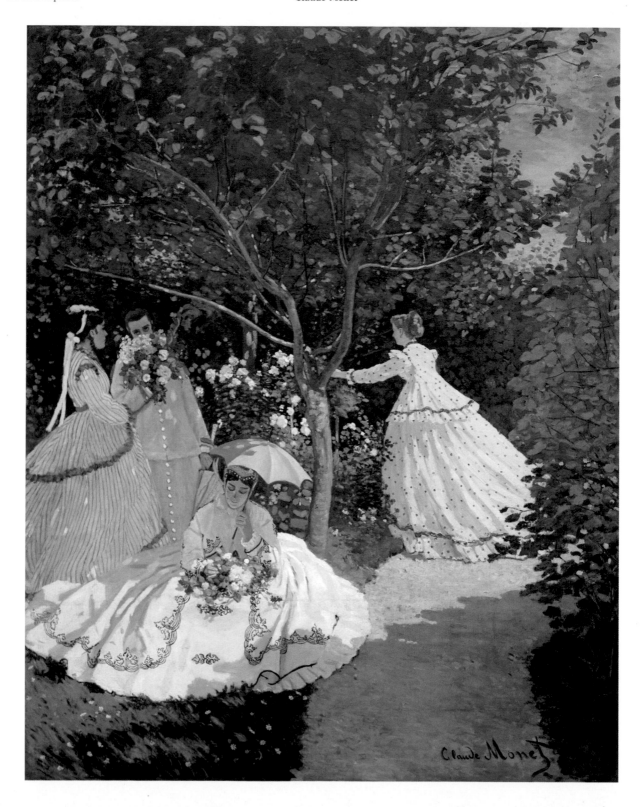

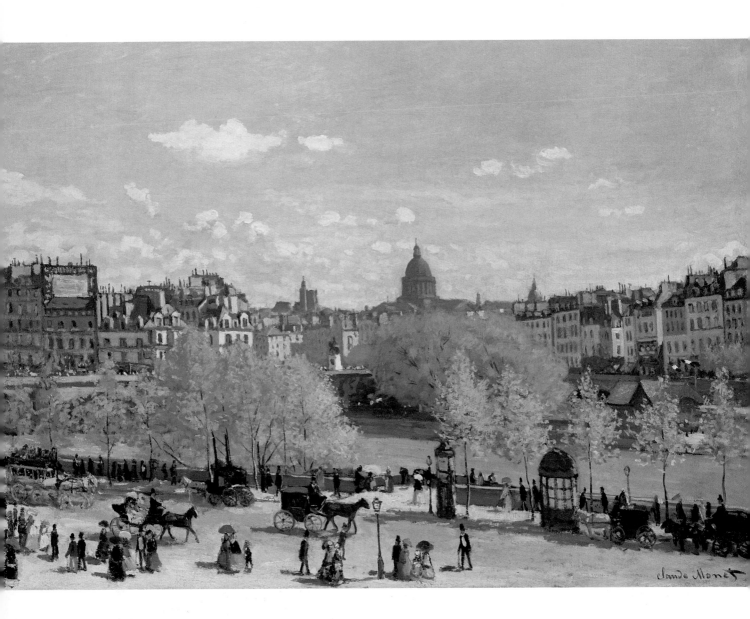

Women in the Garden, 1866–67
© Musée d'Orsay, Paris, France, Giraudon/The Bridgeman Art Library
Medium: Oil on canvas

Quai du Louvre, 1866–67
© The Hague Municipal Museum, The Hague, Netherlands/The Bridgeman Art Library
Medium: Oil on canvas

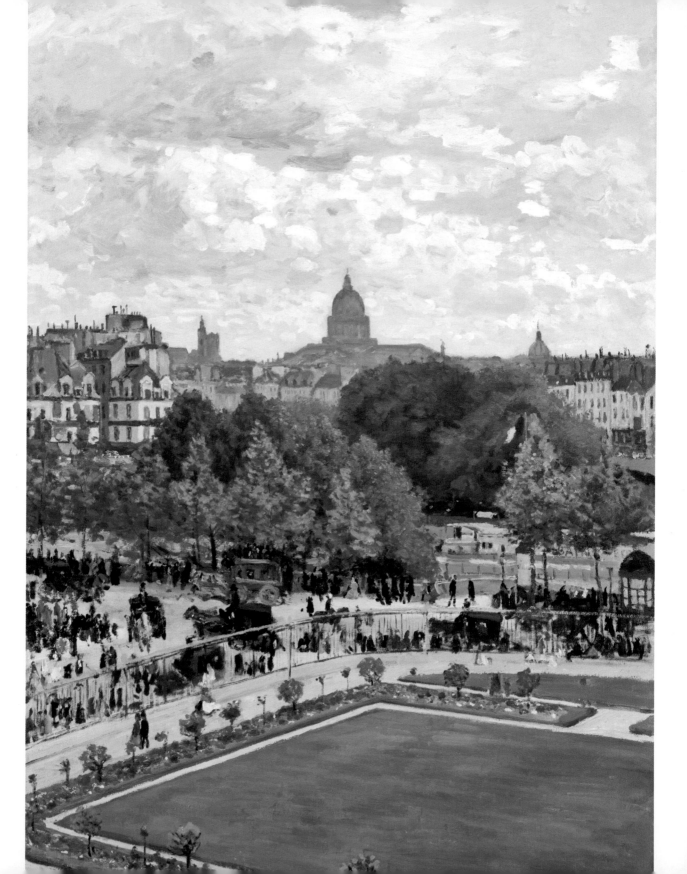

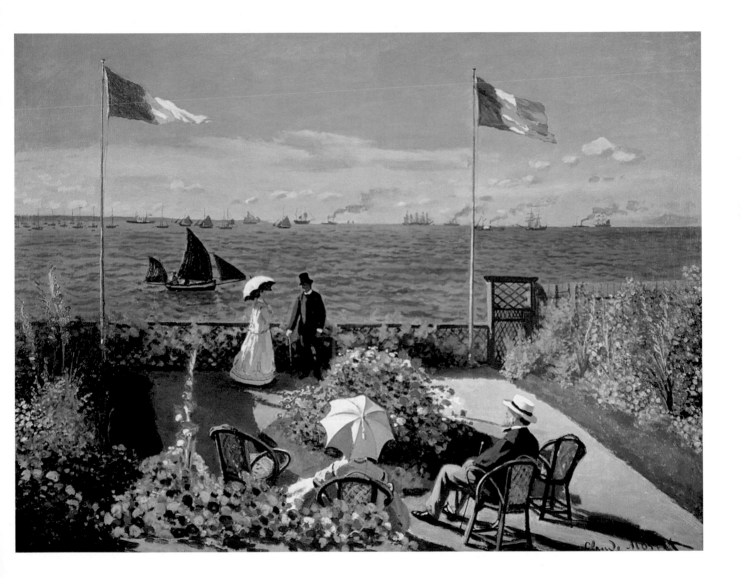

Garden of the Princess, Louvre, 1867
© Allen Memorial Art Museum, Oberlin College, Ohio, USA/R.T. Miller, Jr. Fund/The Bridgeman Art Library
Medium: Oil on canvas

Terrace at Sainte-Adresse, 1867
© Metropolitan Museum of Art, New York, USA/Giraudon/The Bridgeman Art Library
Medium: Oil on canvas

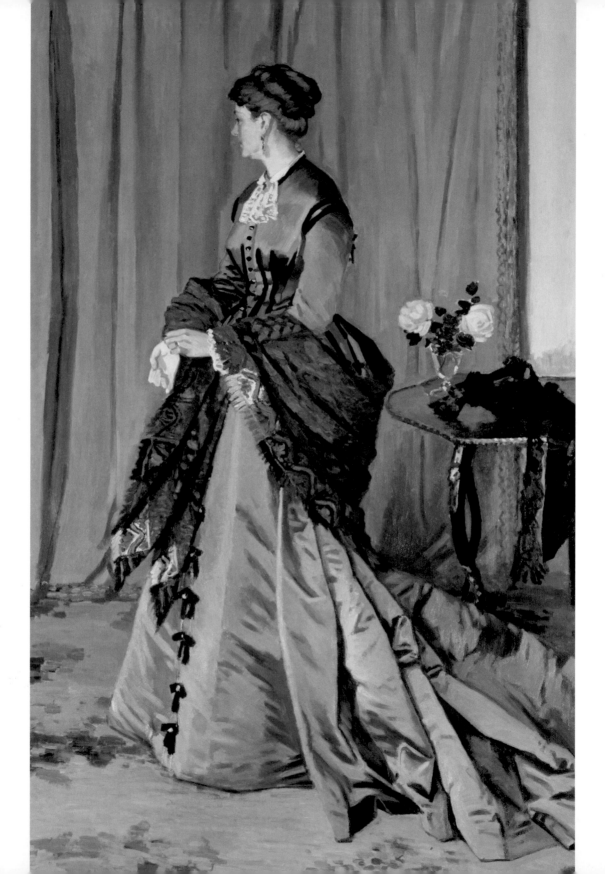

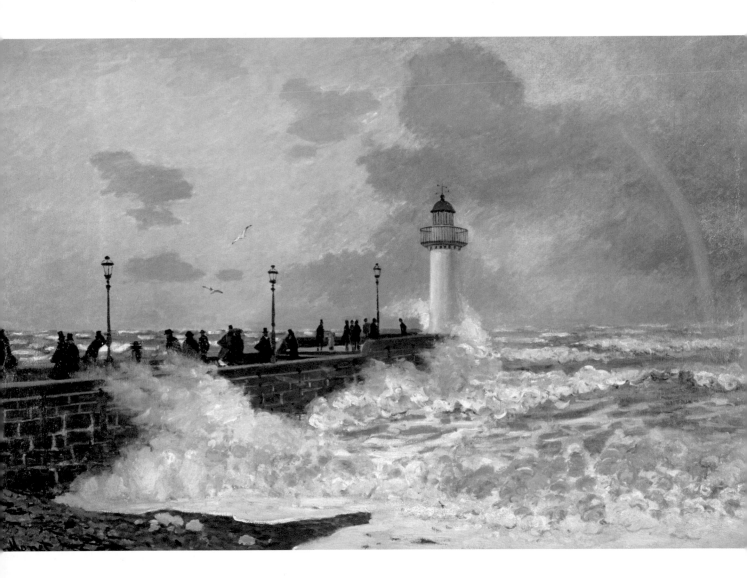

Portrait of Madame Louis Joachim Gaudibert, 1868
© Musée d'Orsay, Paris, France, Lauros/Giraudon/The Bridgeman Art Library
Medium: Oil on canvas

The Jetty of Le Havre, 1868
© Christie's Images Ltd
Medium: Oil on canvas

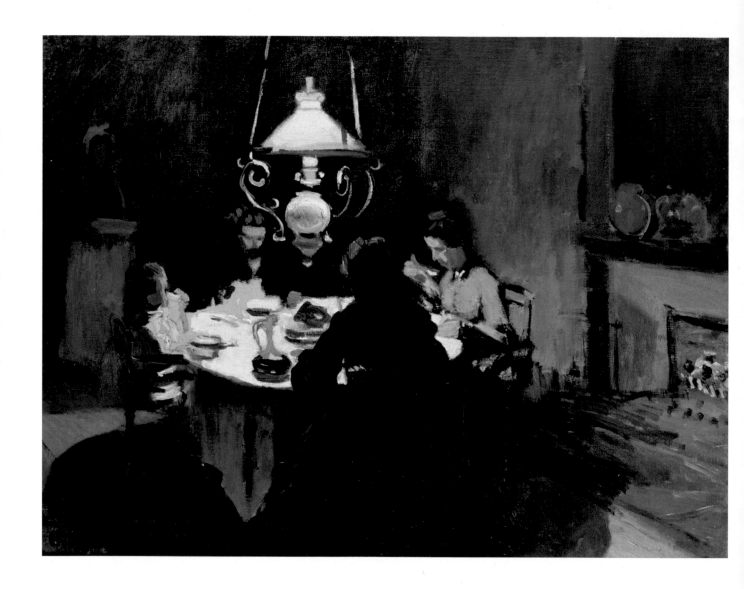

The Dinner, 1868–69
© Buhrle Collection, Zurich, Switzerland/The Bridgeman Art Library
Medium: Oil on canvas

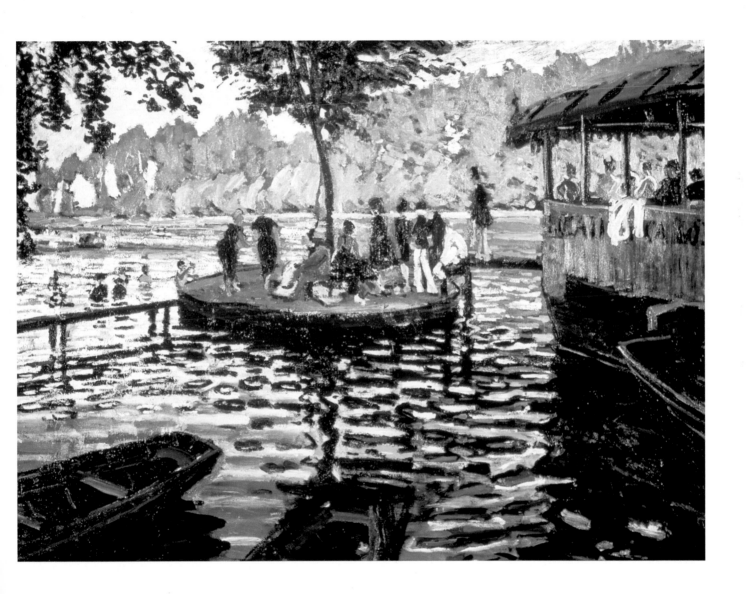

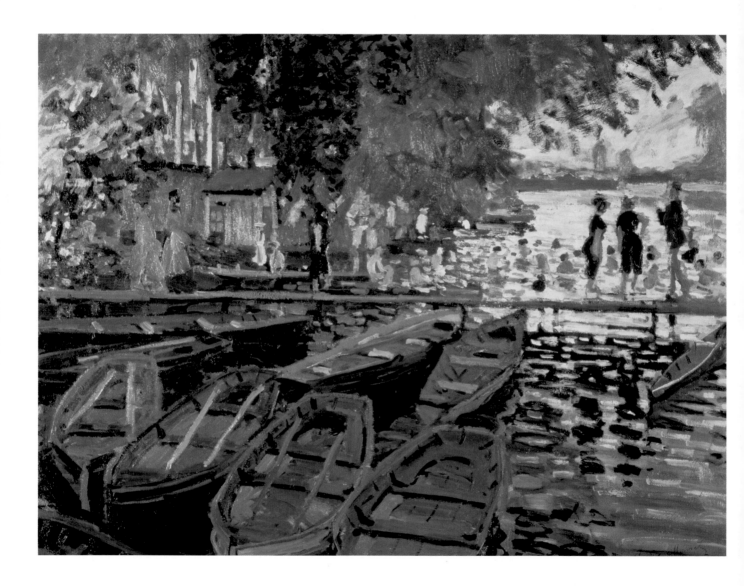

Bathers at La Grenouillère, **1869**
© National Gallery, London, UK/The Bridgeman Art Library
Medium: Oil on canvas

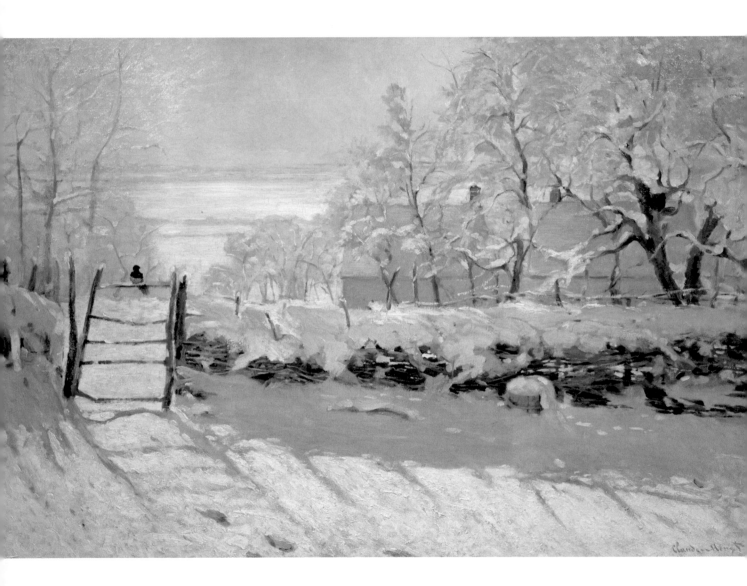

The Magpie, 1869
© Musée d'Orsay, Paris, France/Giraudon/The Bridgeman Art Library
Medium: Oil on canvas

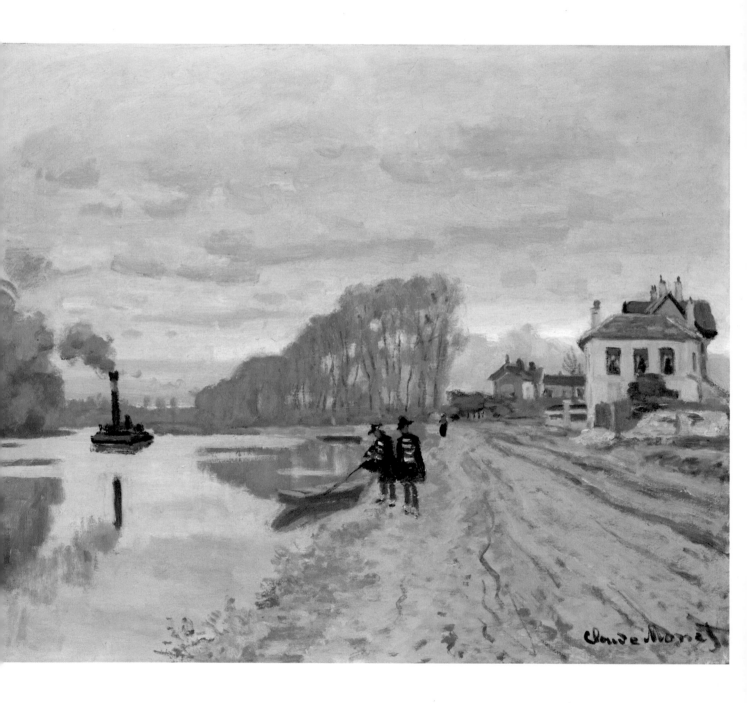

Infantrymen of the Flanant Guard on the Water, 1870
Private Collection/Photo © Christie's Images Ltd/The Bridgeman Art Library
Medium: Oil on canvas

The Red Cape (Madame Monet), c. 1870
© Cleveland Museum of Art, OH, USA/Giraudon/The Bridgeman Art Library
Medium: Oil on canvas

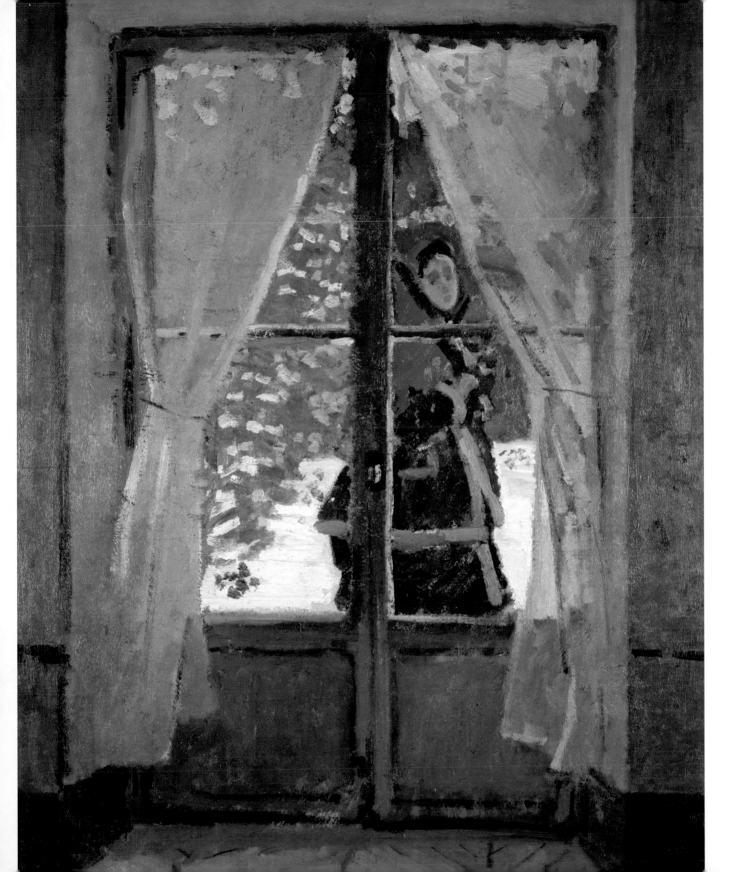

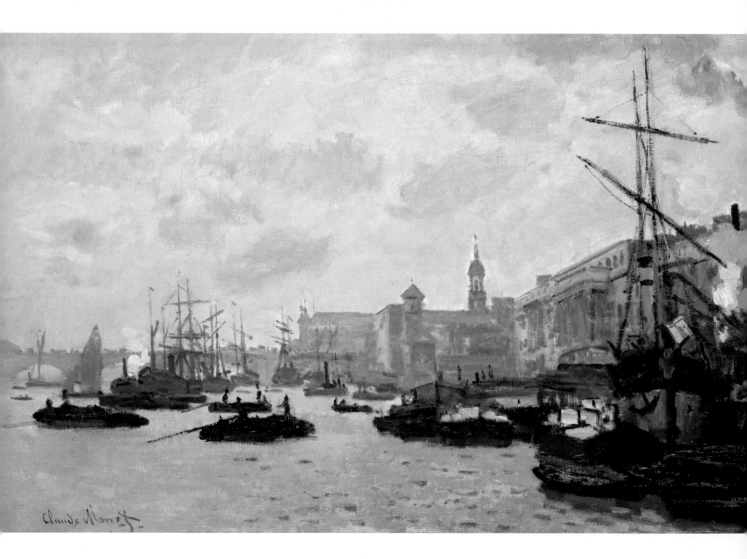

***The Thames at London*, 1871**
© National Museum Wales/The Bridgeman Art Library
Medium: Oil on canvas

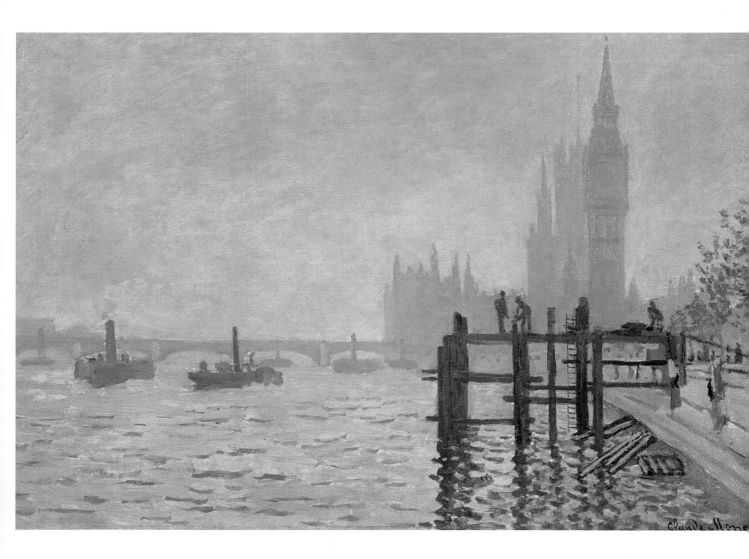

***The Thames below Westminster,* 1871**
© National Gallery, London, UK/The Bridgeman Art Library
Medium: Oil on canvas

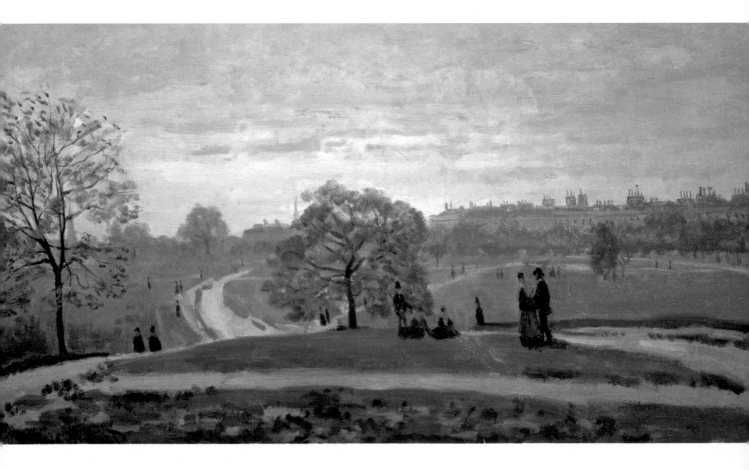

Hyde Park, c. 1871
© Museum of Art, Rhode Island School of Design, USA/The Bridgeman Art Library
Medium: Oil on canvas

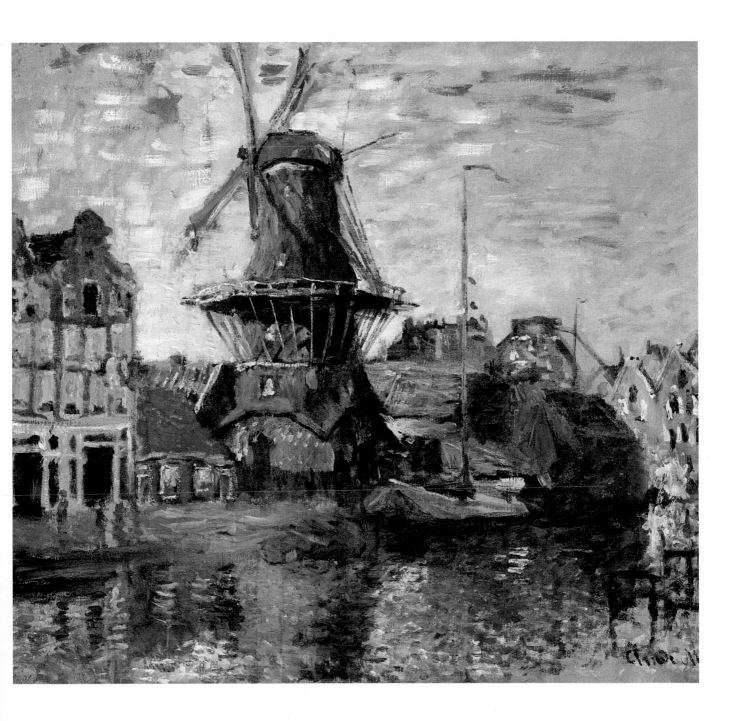

The Windmill, Amsterdam, **1871**
© Museum of Fine Arts, Houston, Texas, USA/Gift of Audrey Jones Beck/The Bridgeman Art Library
Medium: Oil on canvas

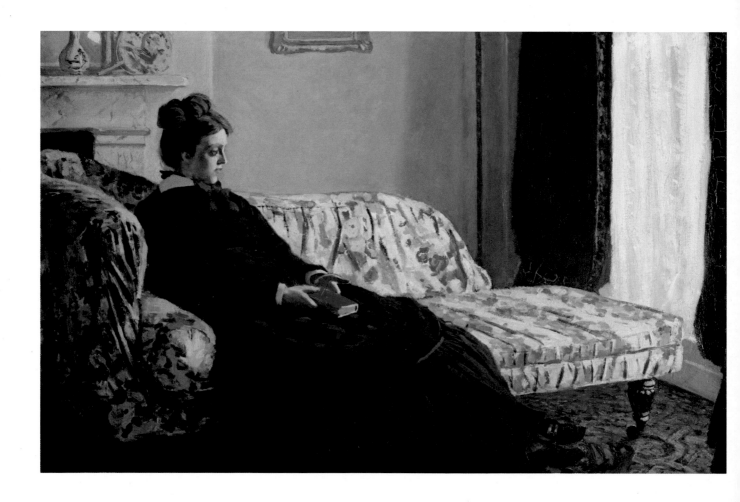

Meditation, or *Madame Monet on the Sofa, c.* 1871
© Musée d'Orsay, Paris, France/Giraudon/The Bridgeman Art Library
Medium: Oil on canvas

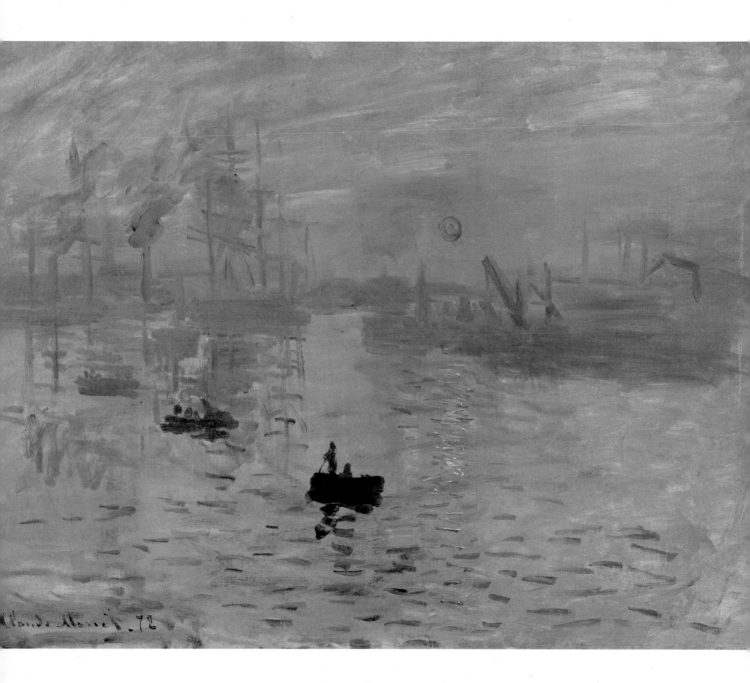

Impression: Sunrise, Le Havre, 1872
Medium: Oil on canvas

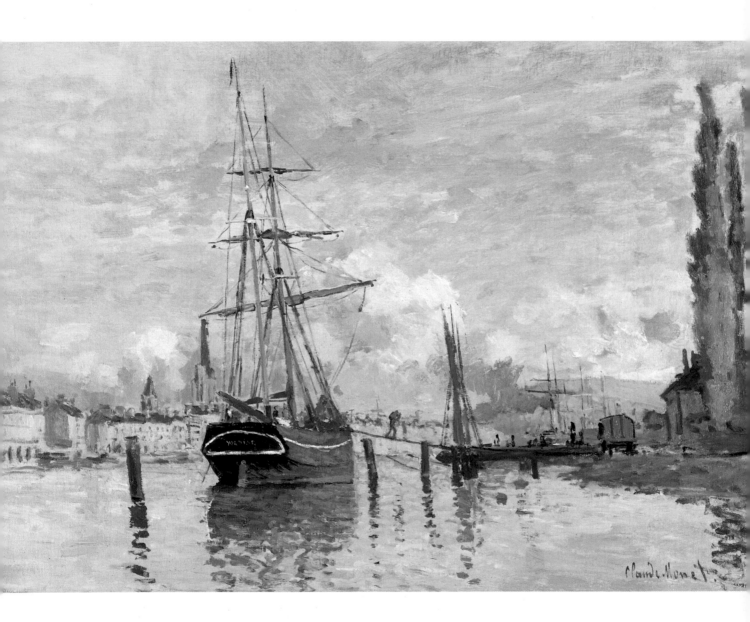

The Seine at Rouen, **date unknown**
Private Collection/Photo © Christie's Images/The Bridgeman Art Library
Medium: Oil on canvas

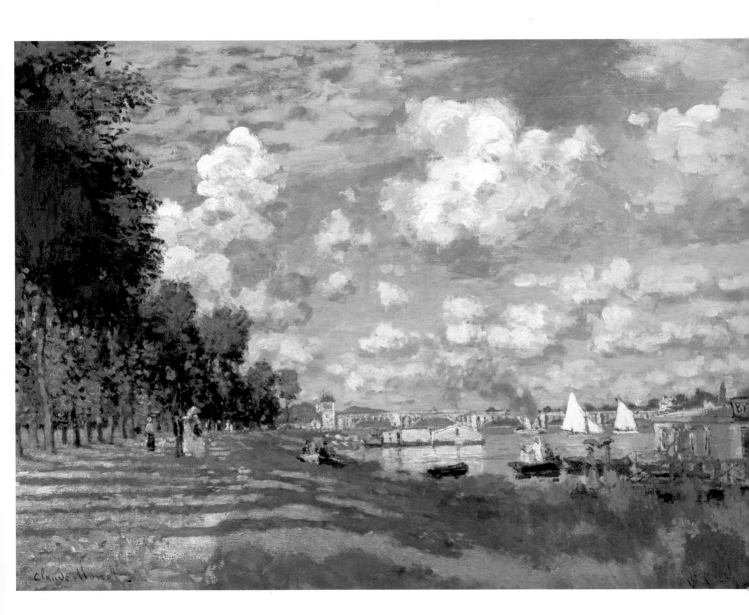

The Marina at Argenteuil, 1872
© Musée d'Orsay, Paris, France/Giraudon/The Bridgeman Art Library
Medium: Oil on canvas

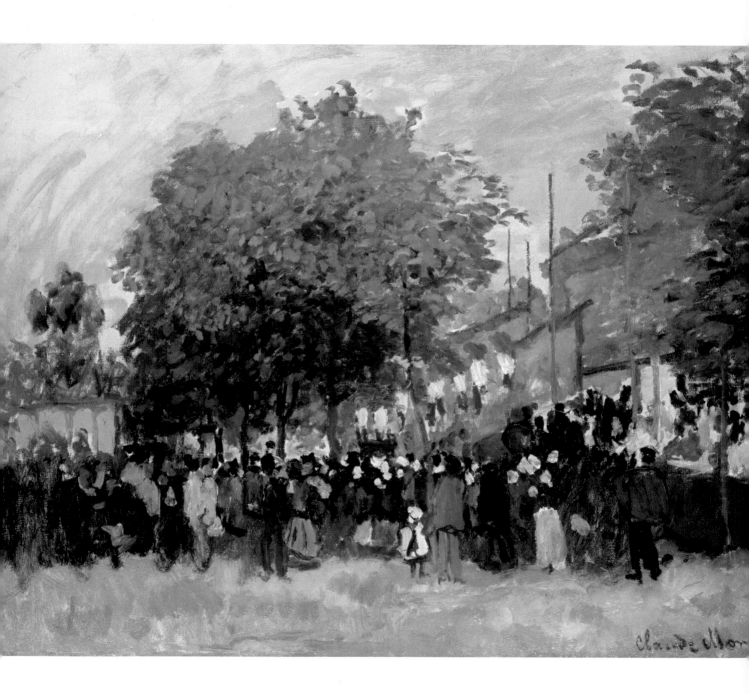

The Fourteenth of July, Argenteuil, 1872
Private Collection/Photo © Christie's Images Ltd/The Bridgeman Art Library
Medium: Oil on canvas

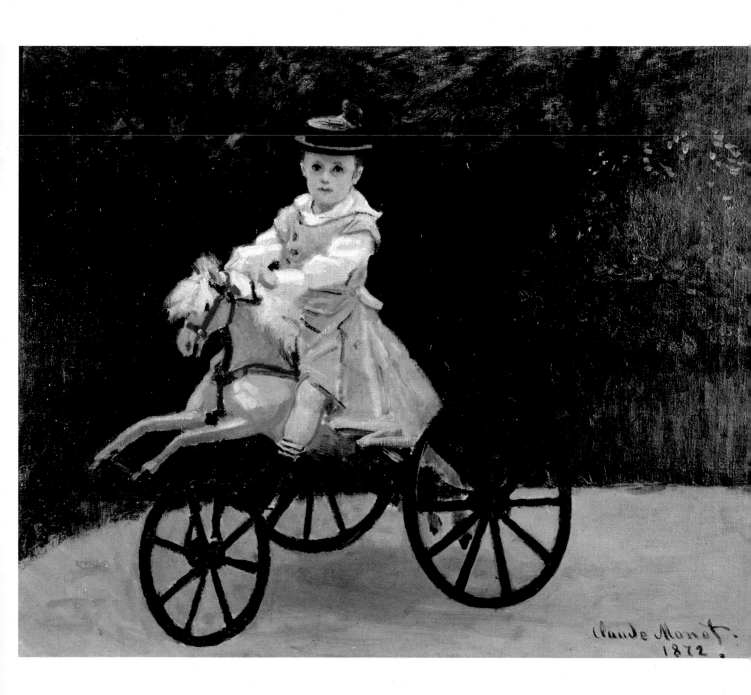

***Jean Monet on His Mechanical Horse,* 1872**
© Metropolitan Museum of Art, New York, USA/Giraudon/The Bridgeman Art Library
Medium: Oil on canvas

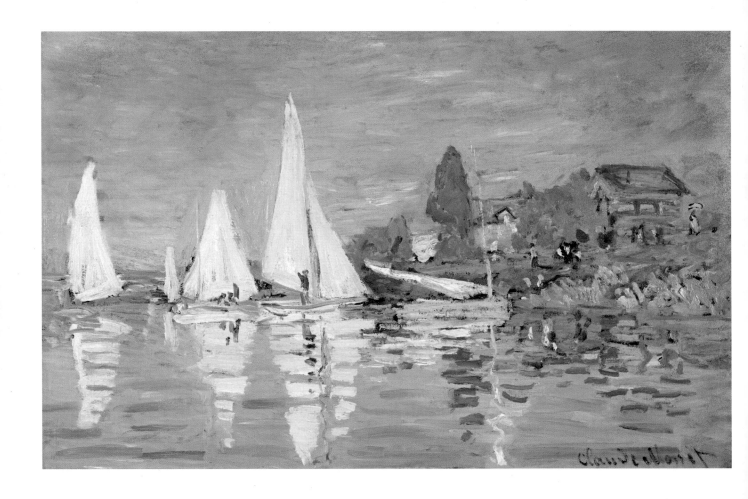

Regatta at Argenteuil, c. 1872
© Musée d'Orsay, Paris, France/Giraudon/The Bridgeman Art Library
Medium: Oil on canvas

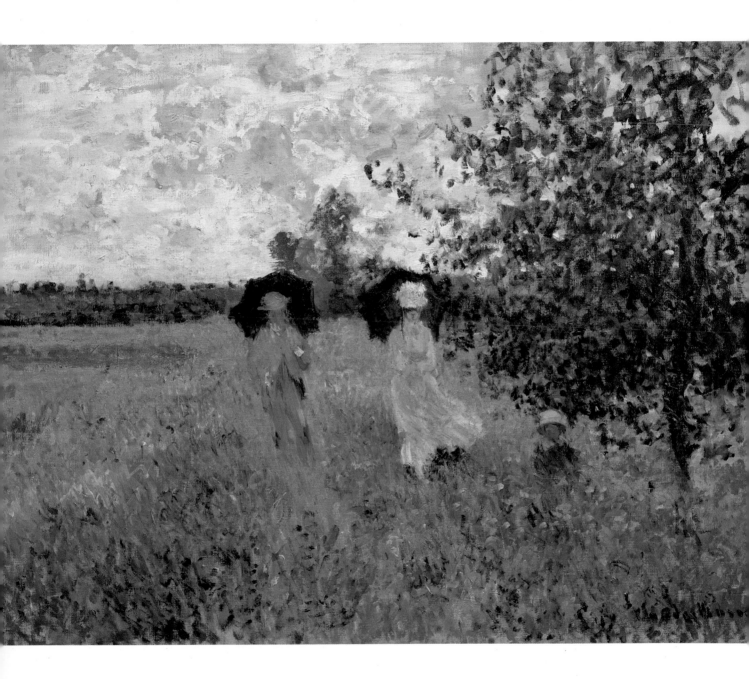

Promenade near Argenteuil, 1873
© Musée Marmottan, Paris, France, Giraudon/The Bridgeman Art Library
Medium: Oil on canvas

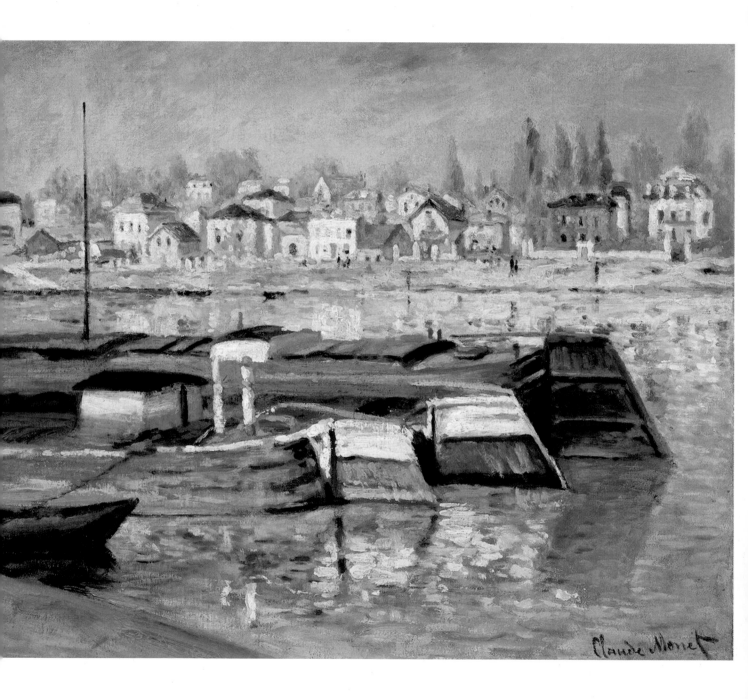

Seine at Asnières, 1873
© Hermitage, St Petersburg, Russia/The Bridgeman Art Library
Medium: Oil on canvas

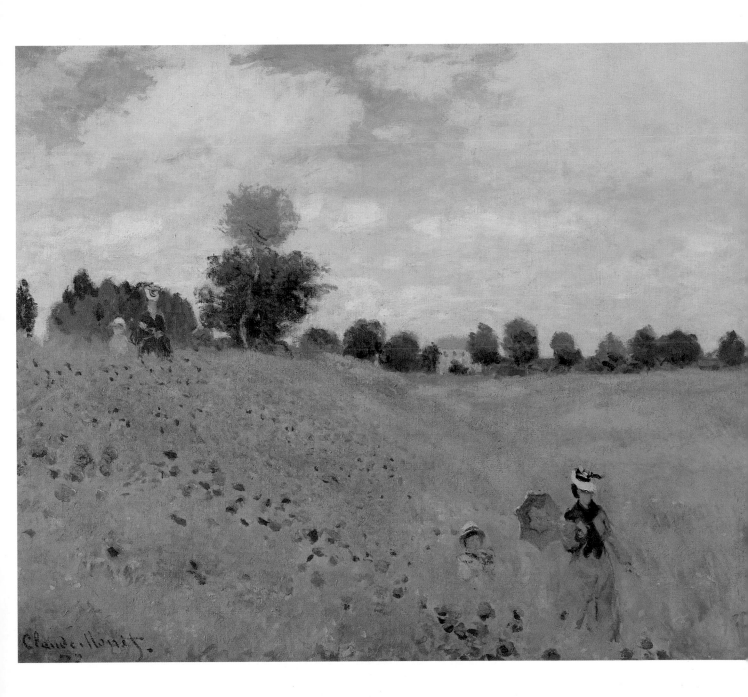

***Wild Poppies near Argenteuil*, 1873**
© Musée d'Orsay, Paris, France, Giraudon/The Bridgeman Art Library
Medium: Oil on canvas

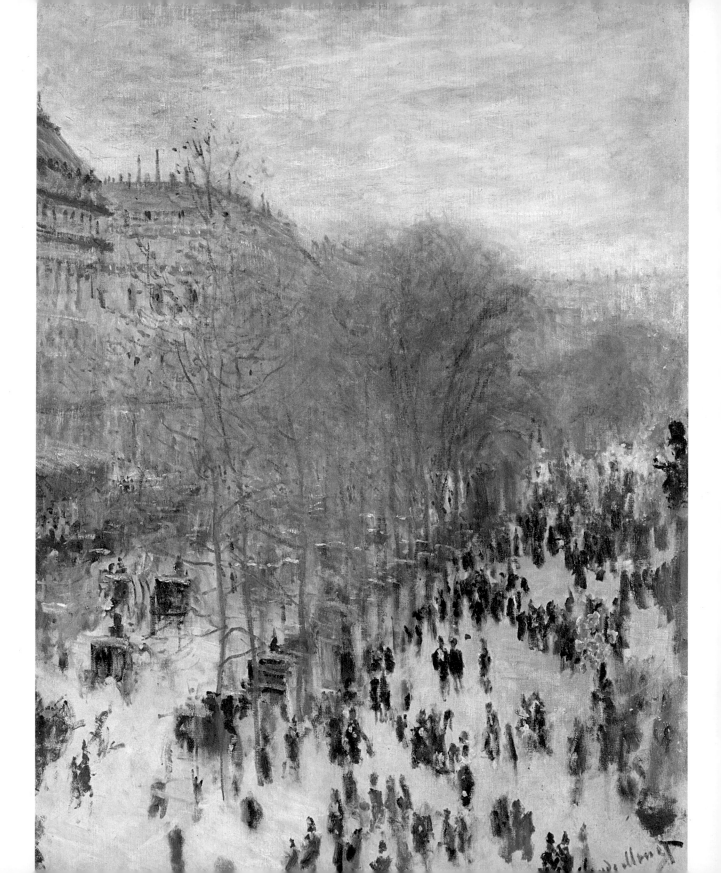

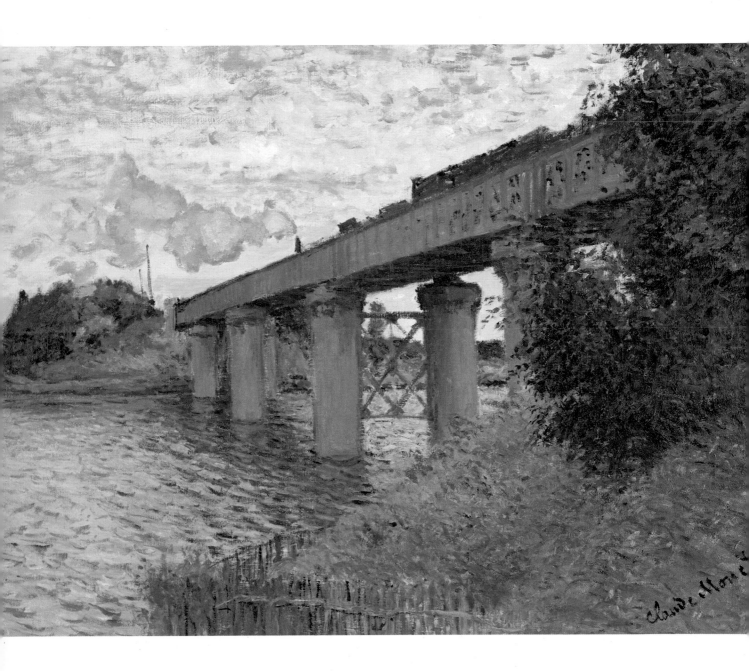

Boulevard des Capucines, 1873–74
Nelson-Atkins Museum of Art, Kansas City, USA/Photo © Boltin Picture Library/The Bridgeman Art Library
Medium: Oil on canvas

The Railway Bridge at Argenteuil, 1873
© Musée d'Orsay, Paris, France/Giraudon/The Bridgeman Art Library
Medium: Oil on canvas

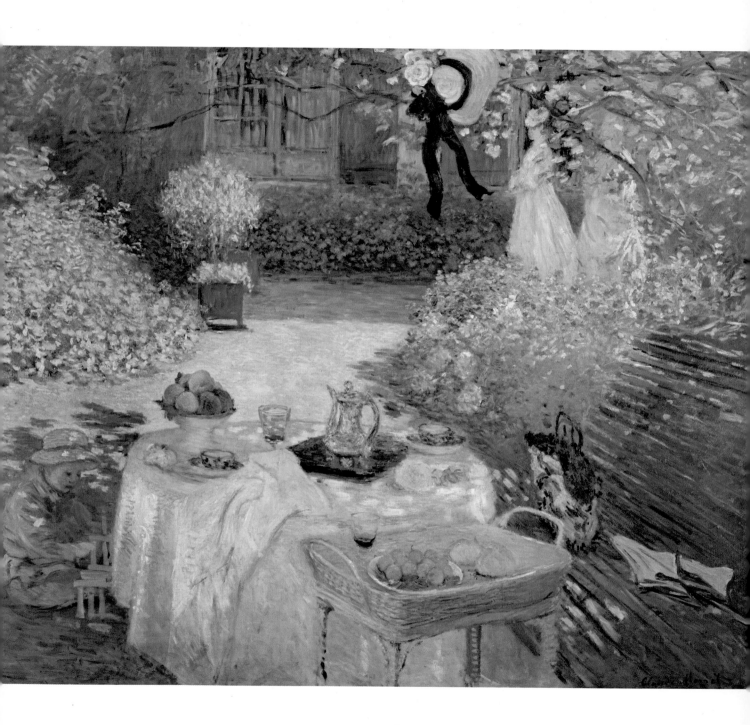

The Luncheon: Monet's garden at Argenteuil, c. 1873
© Musée d'Orsay, Paris, France/Giraudon/The Bridgeman Art Library
Medium: Oil on canvas

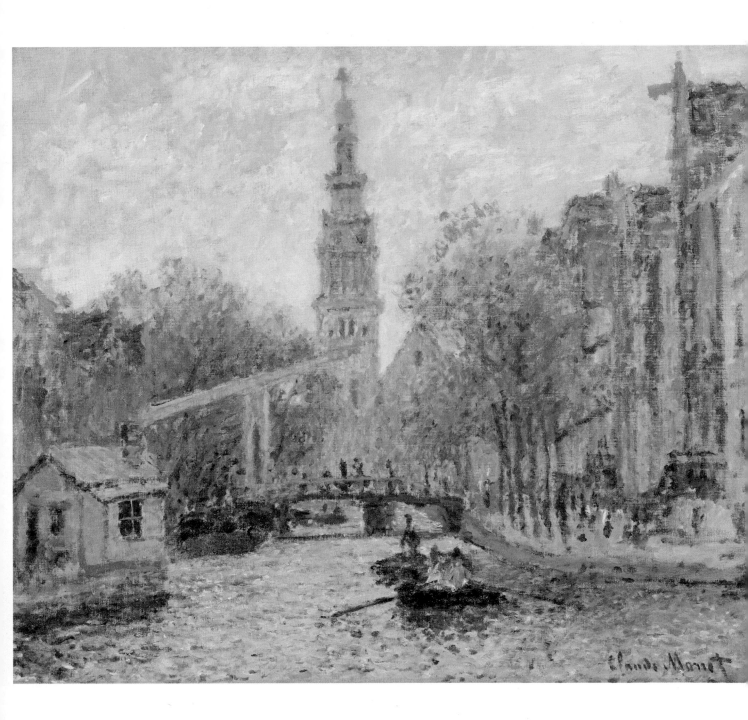

Canal à Amsterdam, **1874**
Private Collection/Photo © Christie's Images/The Bridgeman Art Library
Medium: Oil on canvas

Effect of Snow at Argenteuil, 1874
Private Collection/Photo © Christie's Images Ltd/The Bridgeman Art Library
Medium: Oil on canvas

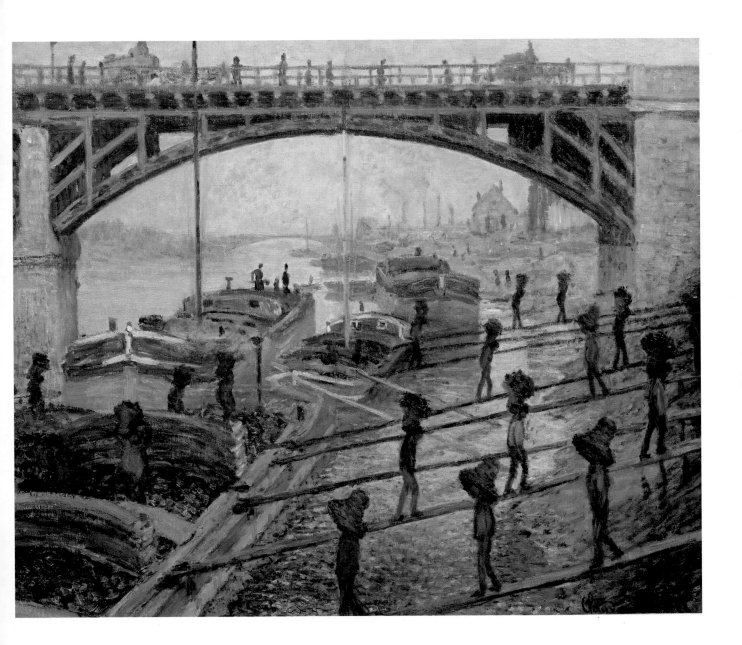

The Coal Workers, **1875**
© Musée d'Orsay, Paris, France, Giraudon/The Bridgeman Art Library
Medium: Oil on canvas

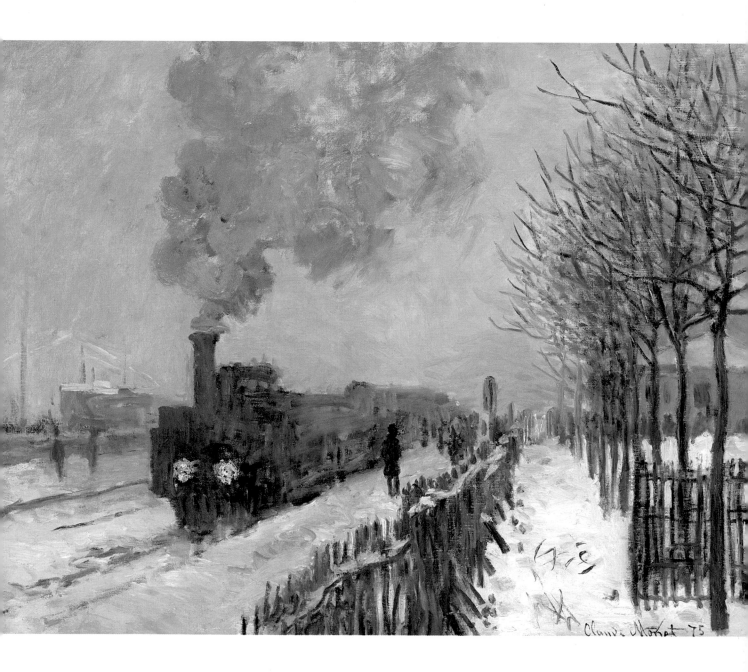

The Locomotive, 1875
© Musée Marmottan, Paris, France/Giraudon/The Bridgeman Art Library
Medium: Oil on canvas

Madame Monet Embroidering, 1875
© The Barnes Foundation, Merion, Pennsylvania, USA/The Bridgeman Art Library
Medium: Oil on canvas

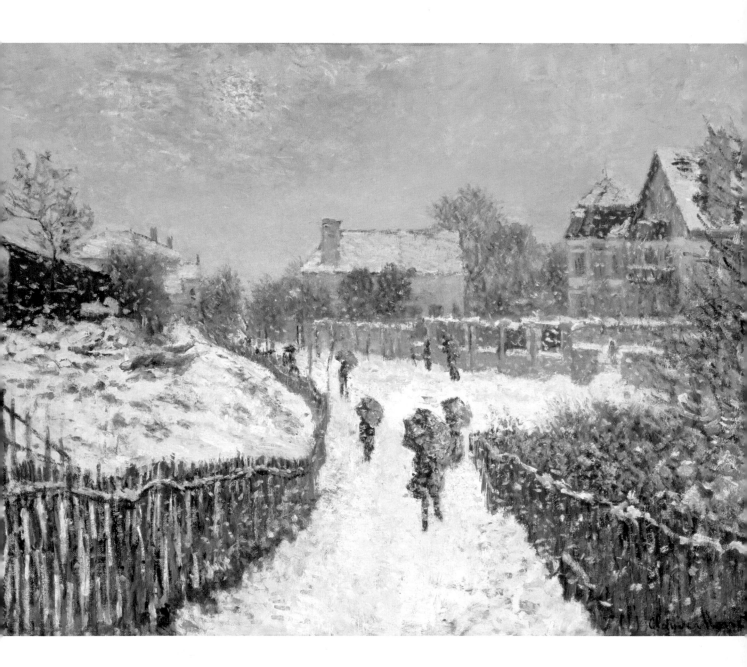

Boulevard Saint-Denis, Argenteuil, in Winter, **1875**
© Museum of Fine Arts, Boston, Massachusetts, USA/Gift of Richard Saltonstall.
All Rights Reserved/The Bridgeman Art Library
Medium: Oil on canvas

Woman with a Parasol – Madame Monet and Her Son, **1875**
National Gallery of Art, Washington DC, USA/Photo © AISA/The Bridgeman Art Library
Medium: Oil on canvas

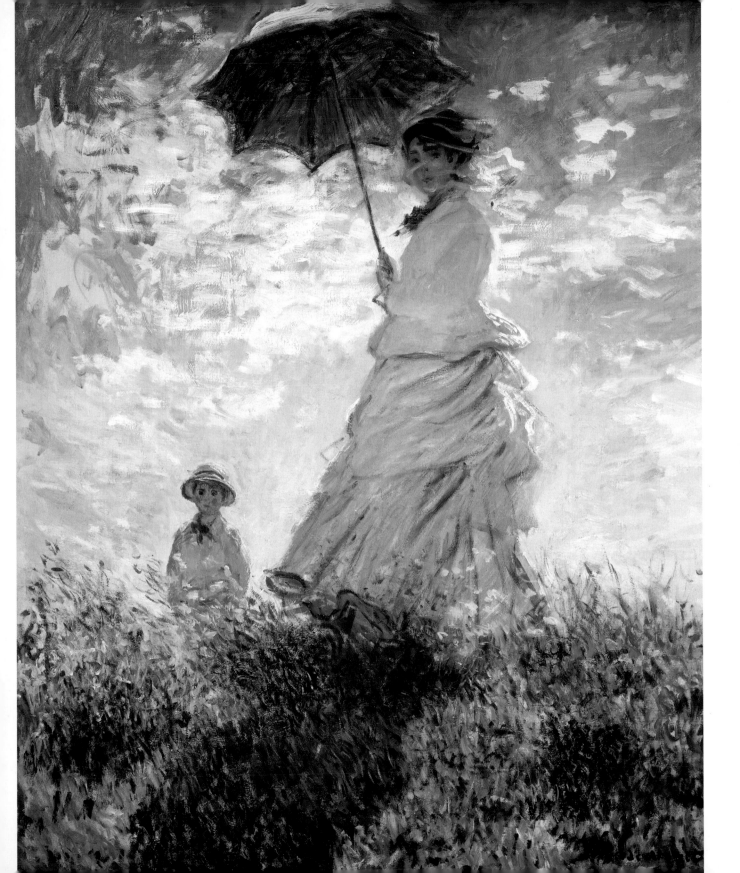

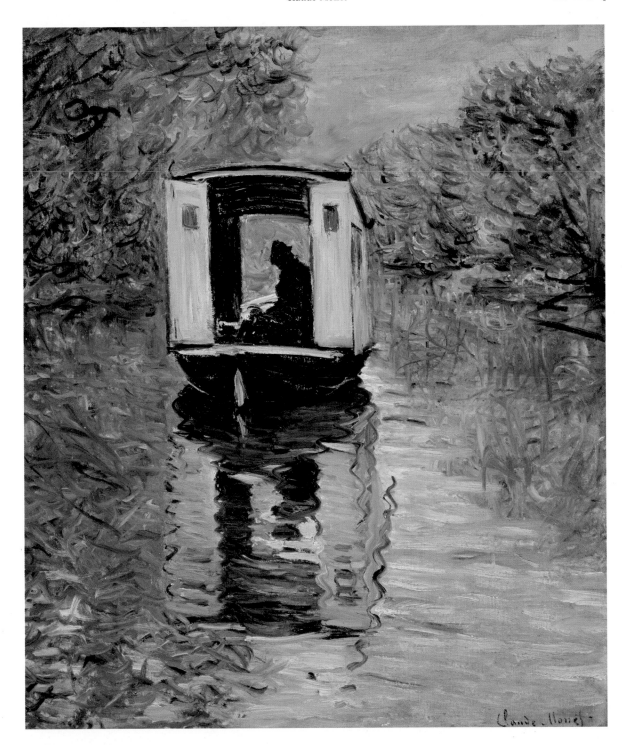

***Corner of a Flat at Argenteuil*, 1875**
© Musée d'Orsay, Paris, France/Giraudon/The Bridgeman Art Library
Medium: Oil on canvas

***The Studio Boat*, 1876**
© The Barnes Foundation, Merion, Pennsylvania, USA/The Bridgeman Art Library
Medium: Oil on canvas

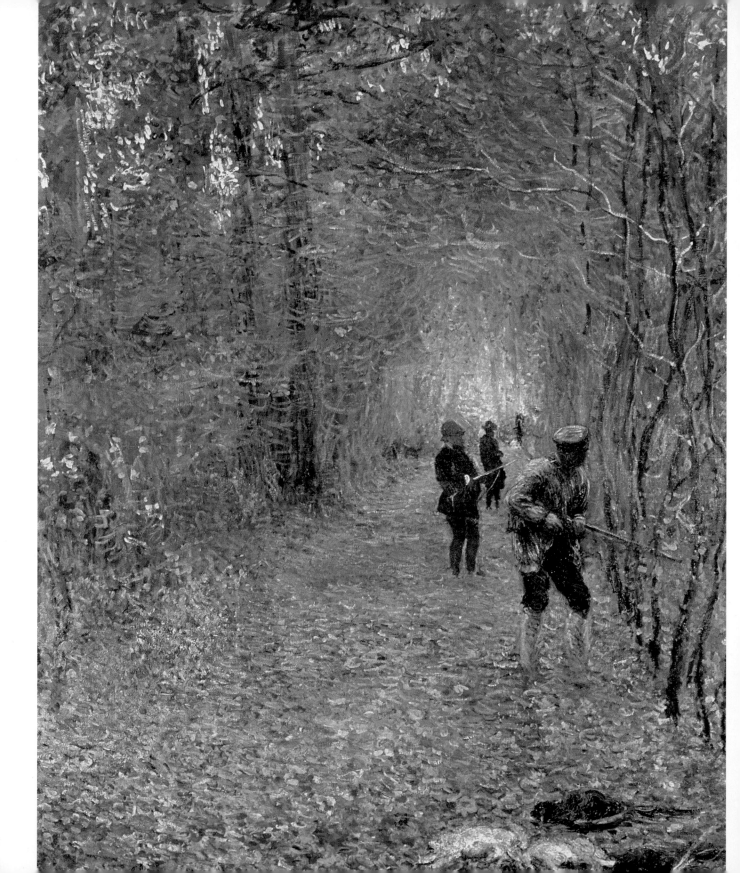

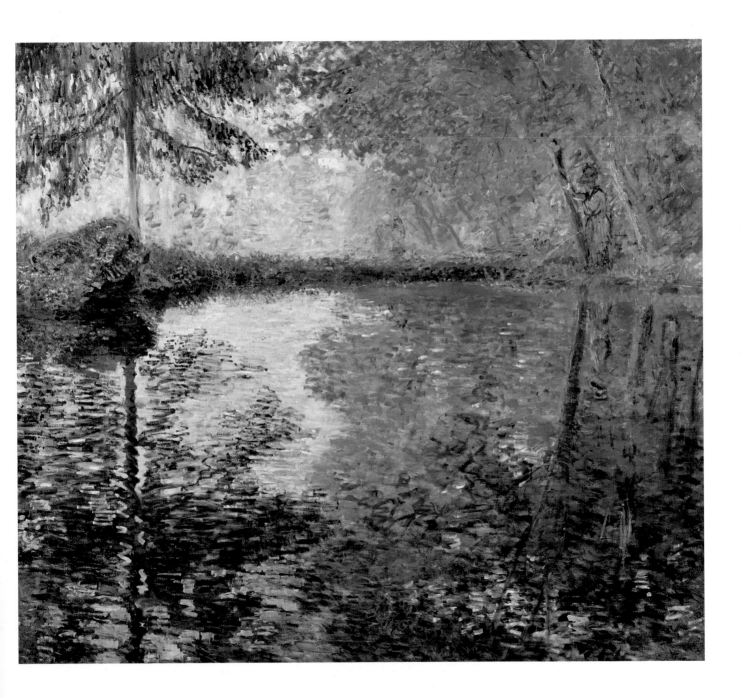

The Shoot, 1876
© Private Collection, Peter Willi/The Bridgeman Art Library
Medium: Oil on canvas

The Lake at Montgeron, 1876
© Hermitage, St Petersburg, Russia/The Bridgeman Art Library
Medium: Oil on canvas

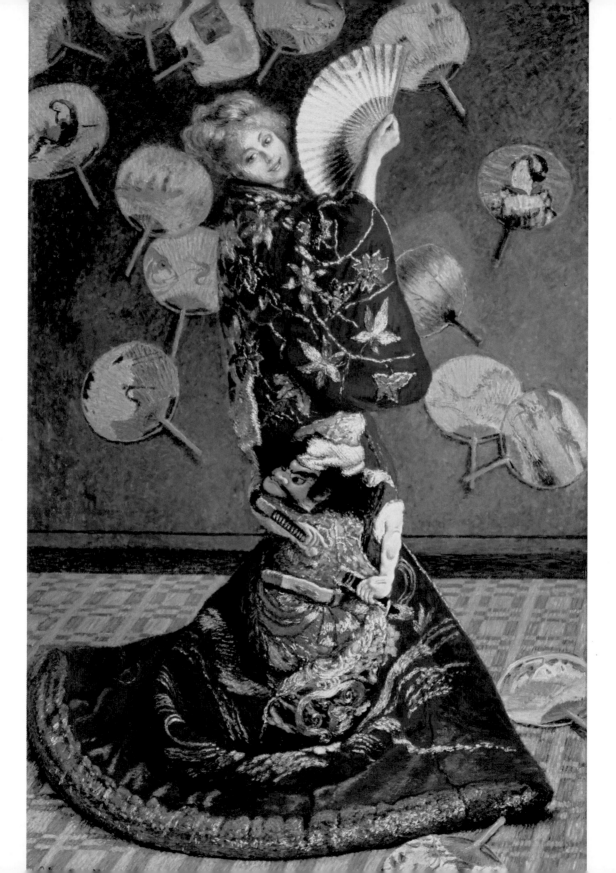

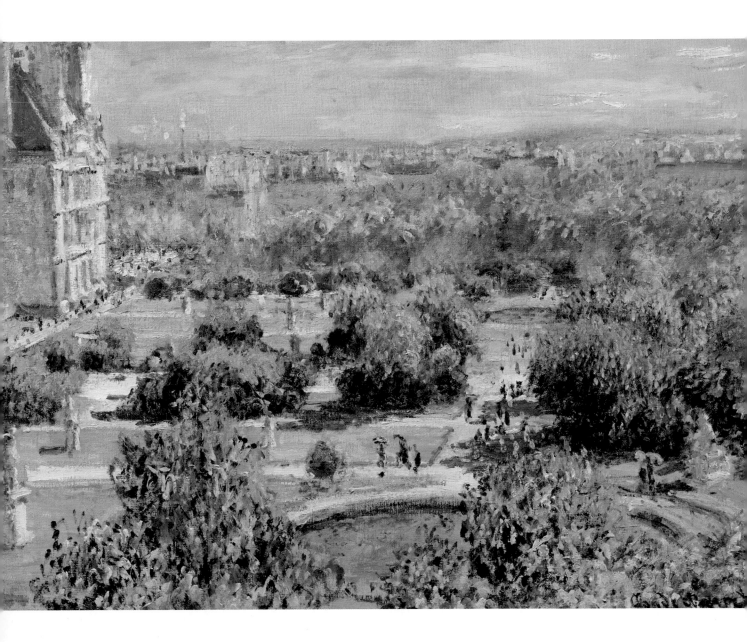

La Japonaise, 1876
© Museum of Fine Arts, Boston, Massachusetts, USA, 1951, Purchase Fund/The Bridgeman Art Library
Medium: Oil on canvas

View of the Tuileries Gardens, Paris, 1876
© Musée Marmottan, Paris, France/The Bridgeman Art Library
Medium: Oil on canvas

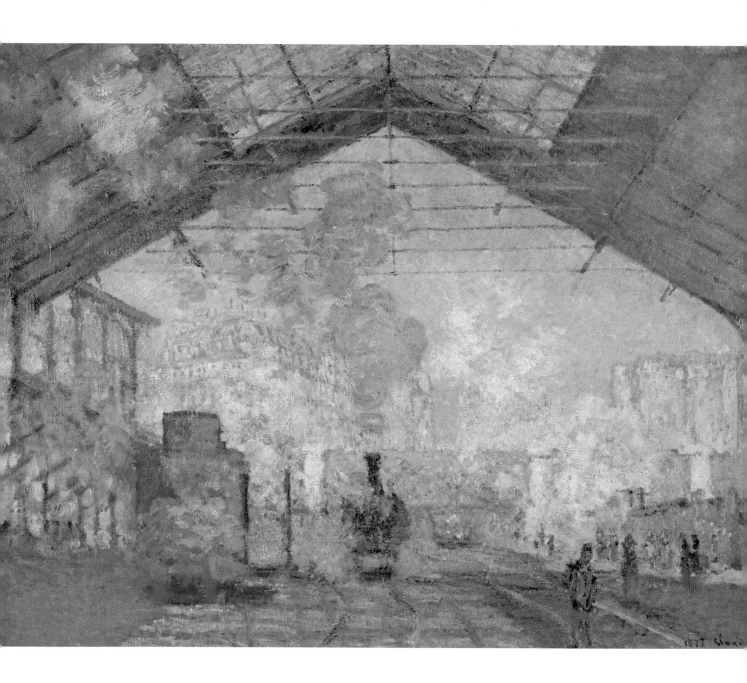

The Gare Saint-Lazare, 1877
© Musée d'Orsay, Paris, France/The Bridgeman Art Library
Medium: Oil on canvas

The Turkeys at the Château de Rottembourg, Montgeron, 1877
© Musée d'Orsay, Paris, France, Giraudon/The Bridgeman Art Library
Medium: Oil on canvas

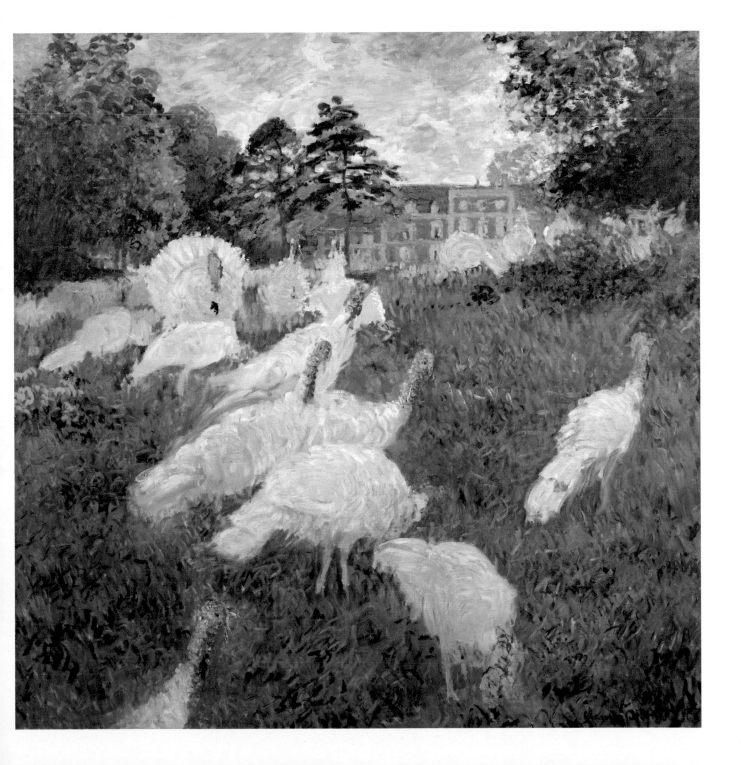

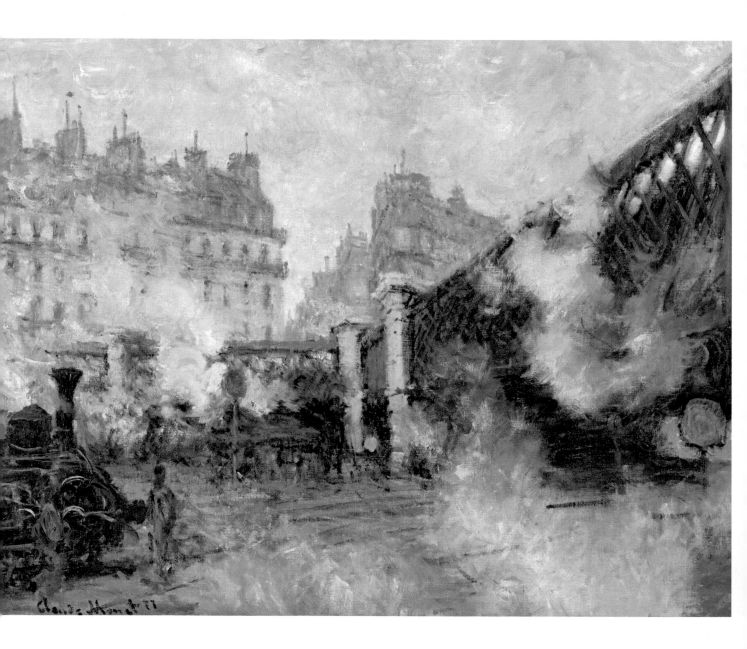

The Pont de l'Europe, Gare Saint-Lazare, 1877
© Musée Marmottan, Paris, France/Giraudon/The Bridgeman Art Library
Medium: Oil on canvas

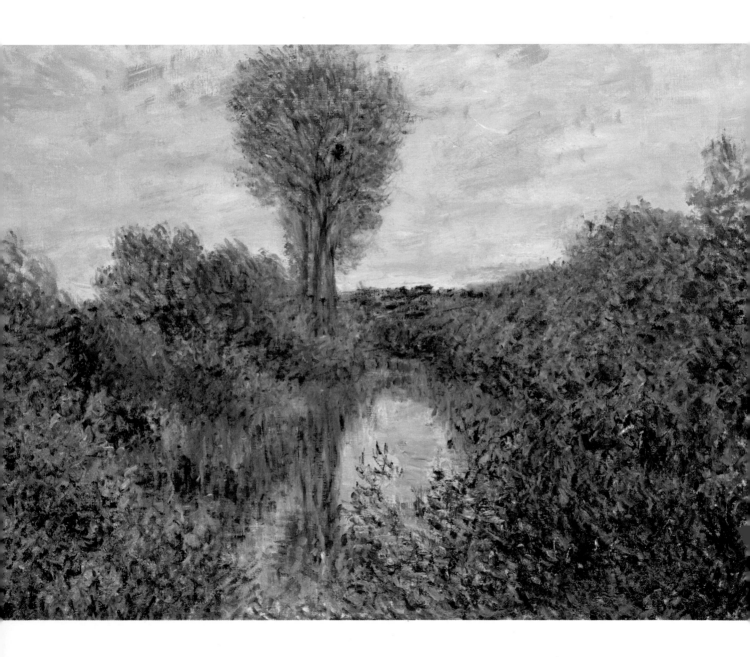

Small Branch of the Seine, **1878**
Private Collection/Photo © Lefèvre Fine Art Ltd., London/The Bridgeman Art Library
Medium: Oil on canvas

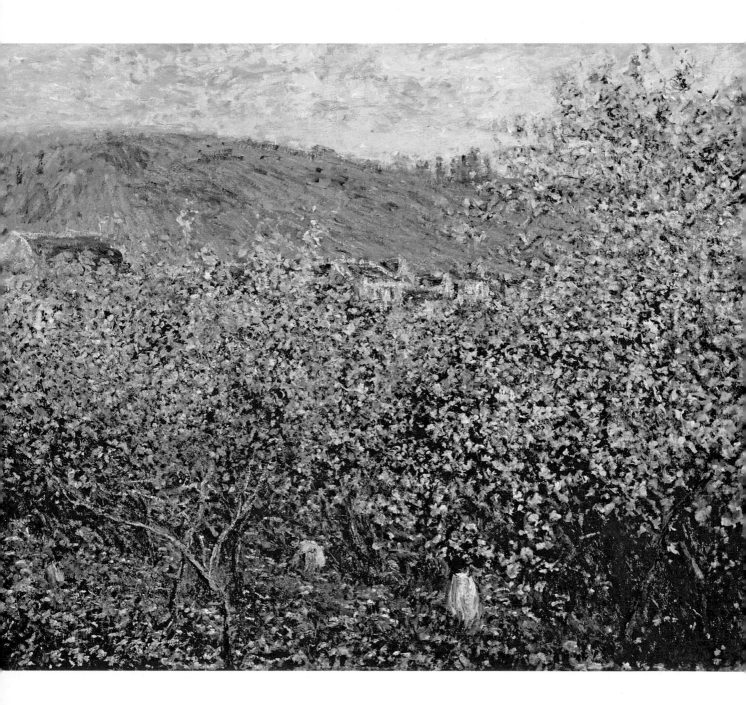

The Rue Saint-Denis, Celebration of June 30, 1878
© Musée des Beaux-Arts, Rouen, France/Giraudon/The Bridgeman Art Library
Medium: Oil on canvas

The Fruit Pickers, 1879
Private Collection/Photo © Boltin Picture Library/The Bridgeman Art Library
Medium: Oil on canvas

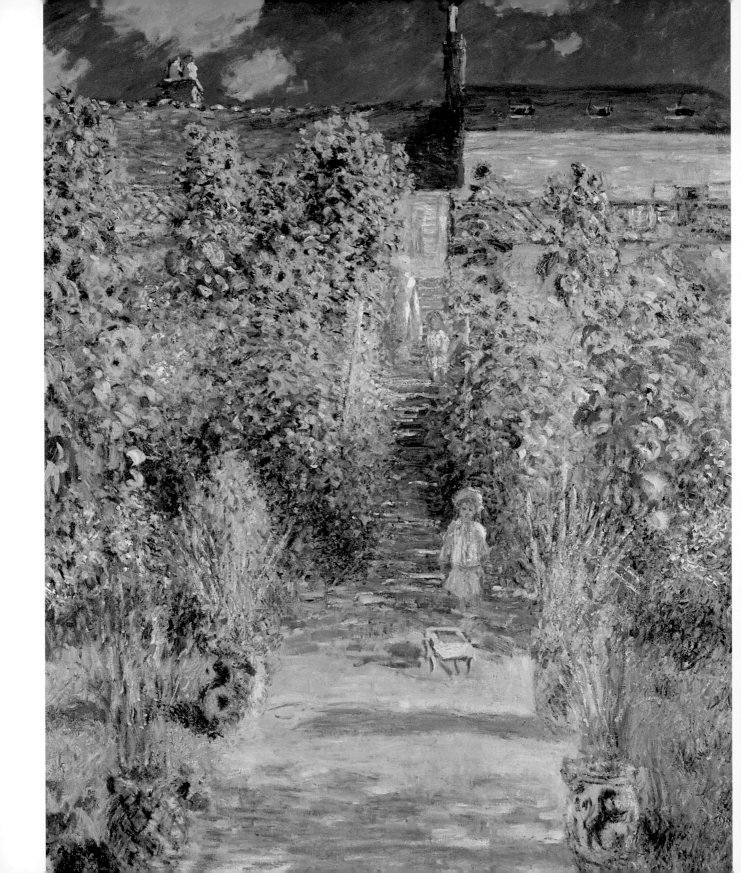

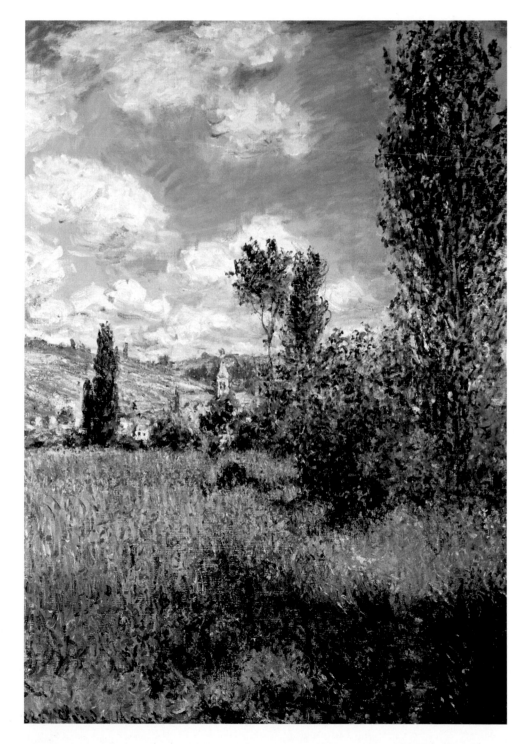

The Artist's Garden at Vétheuil, 1880
© National Gallery of Art, Washington DC, USA/Giraudon/The Bridgeman Art Library
Medium: Oil on canvas

Path through the Poppies, Ile Saint-Martin, Vétheuil, 1880
© Metropolitan Museum of Art, New York, USA/The Bridgeman Art Library
Medium: Oil on canvas

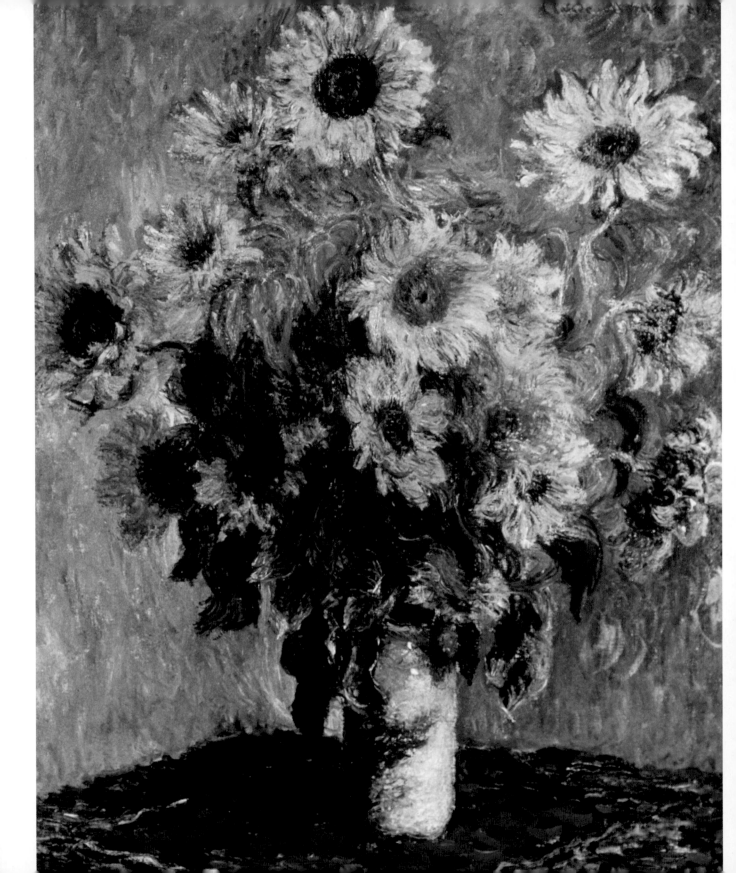

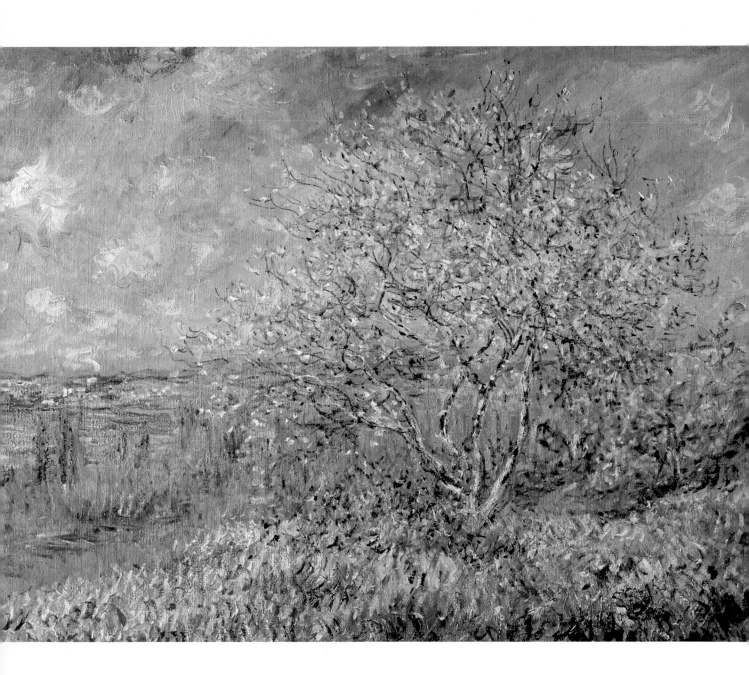

Still Life with Sunflowers, 1881
© Metropolitan Museum of Art, New York, USA/
The Bridgeman Art Library
Medium: Oil on canvas

Spring, 1880–82
© Musée des Beaux-Arts, Lyons, France/
Giraudon/The Bridgeman Art Library
Medium: Oil on canvas

(Next page) *Seascape*, 1881
Private Collection/Photo © Christie's Images/
The Bridgeman Art Library
Medium: Oil on canvas

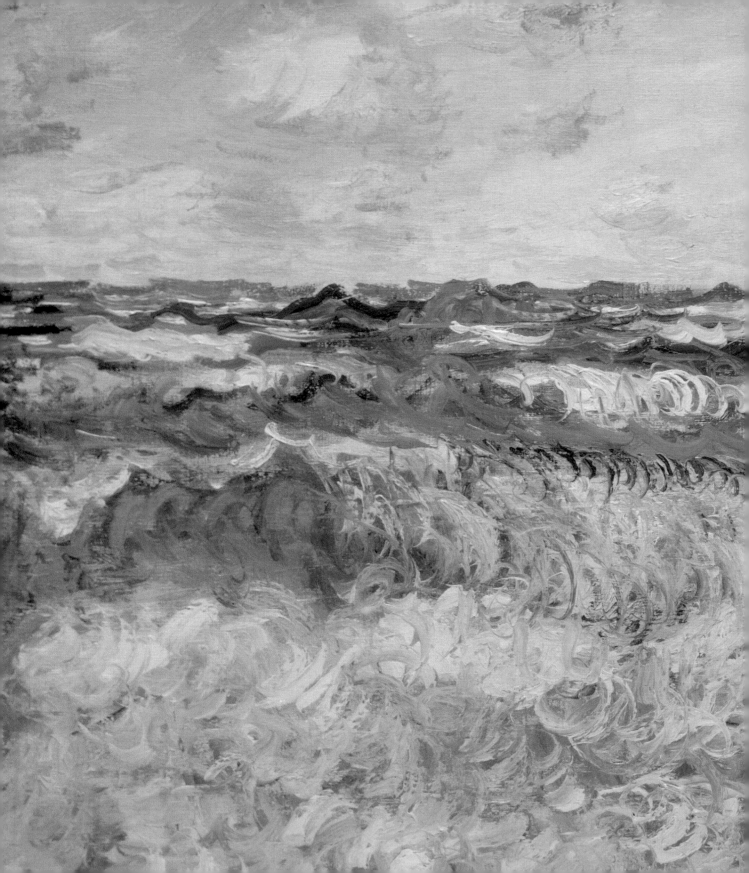

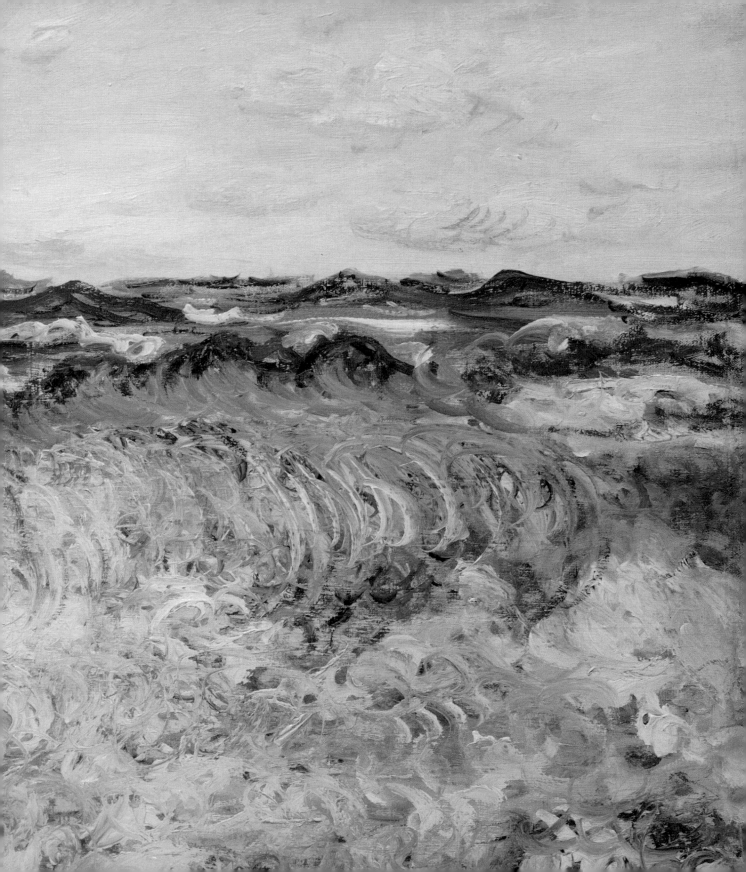

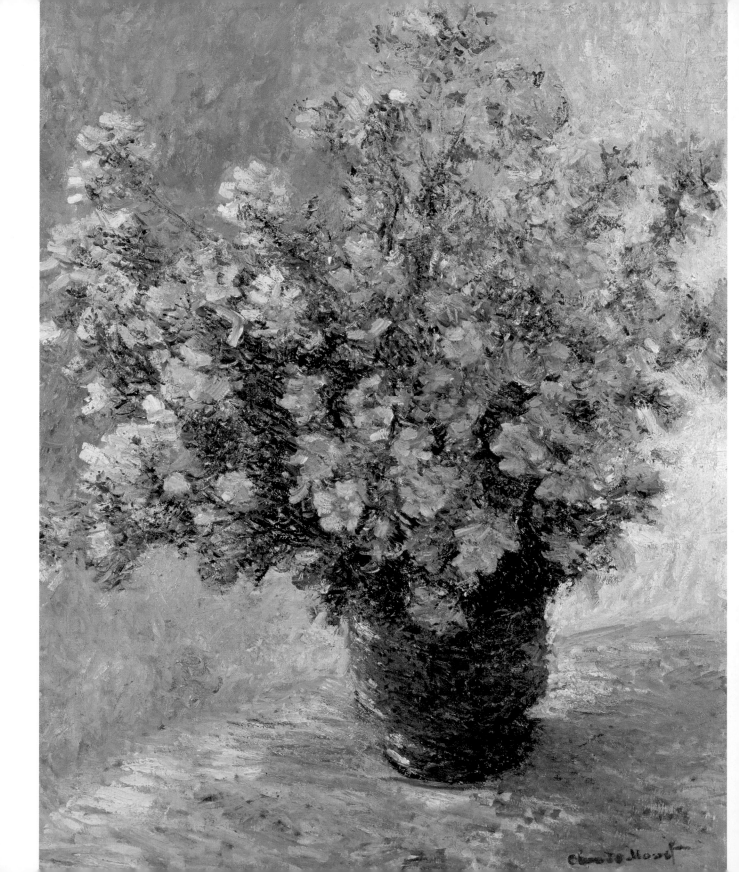

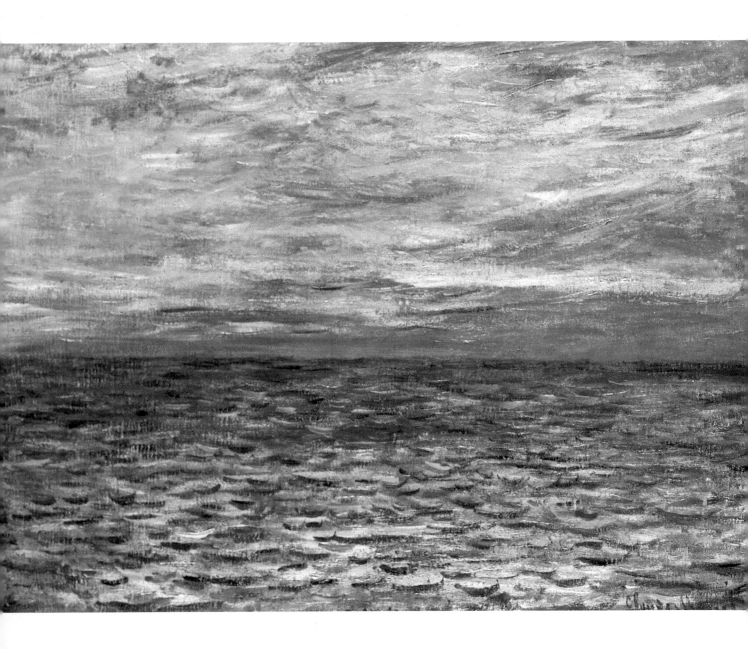

Vase of Flowers, c. 1881–82
© Samuel Courtauld Trust, The Courtauld Gallery, London, UK/The Bridgeman Art Library
Medium: Oil on canvas

Sunset on the Sea at Pourville, 1882
© Christie's Images Ltd
Medium: Oil on canvas

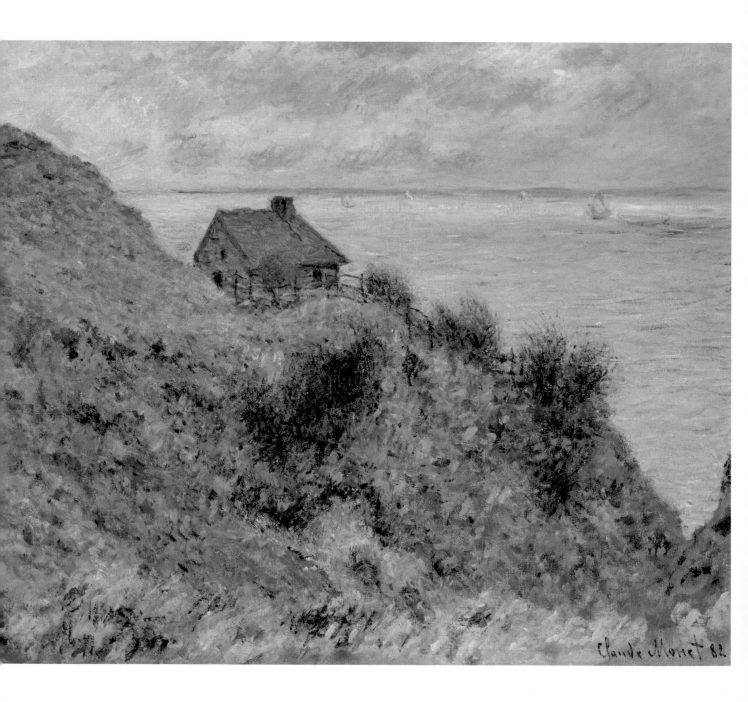

The Customs Officers' Hut at Varengeville, 1882
Private Collection/Photo © Lefevre Fine Art Ltd, London/The Bridgeman Art Library
Medium: Oil on canvas

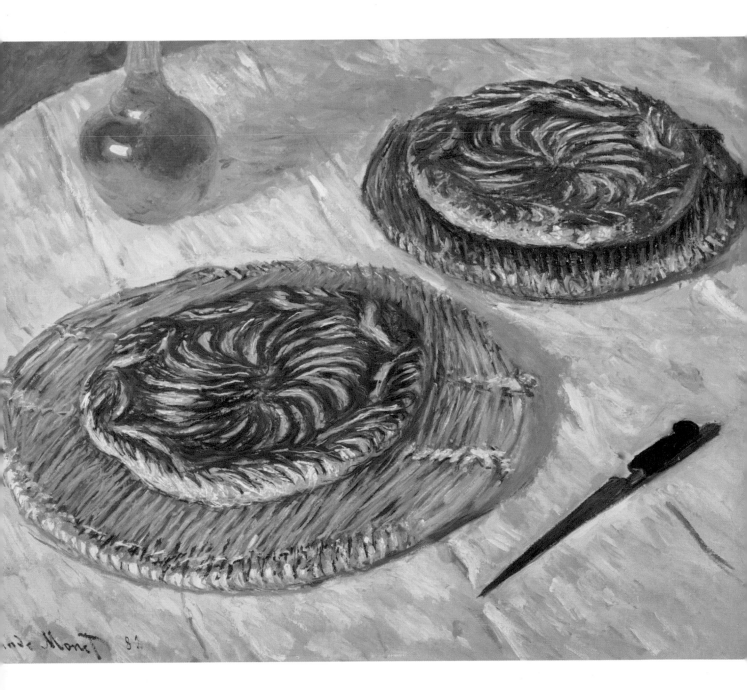

Fruit Tarts, **1882**
© Private Collection/Giraudon/The Bridgeman Art Library
Medium: Oil on canvas

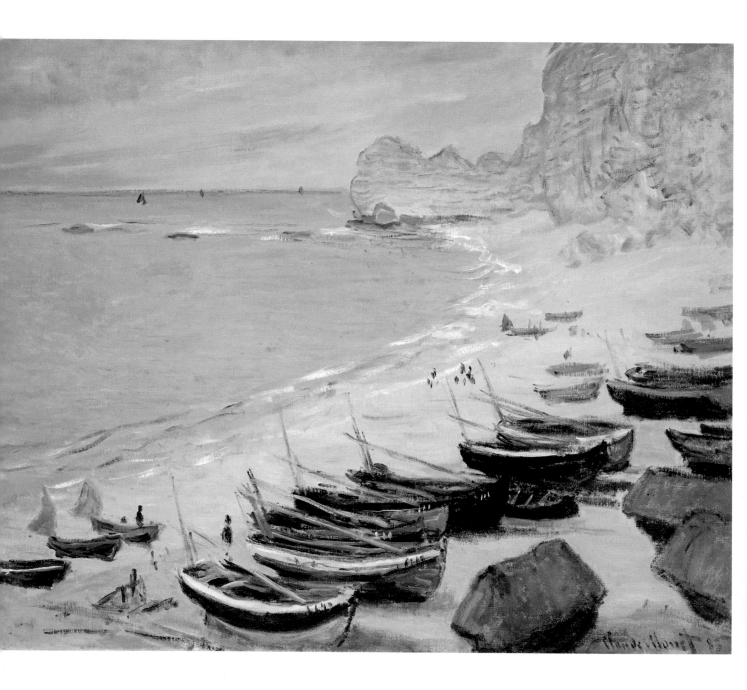

***Boats on the Beach at Etretat,* 1883**
Private Collection/Photo © Christie's Images Ltd/The Bridgeman Art Library
Medium: Oil on canvas

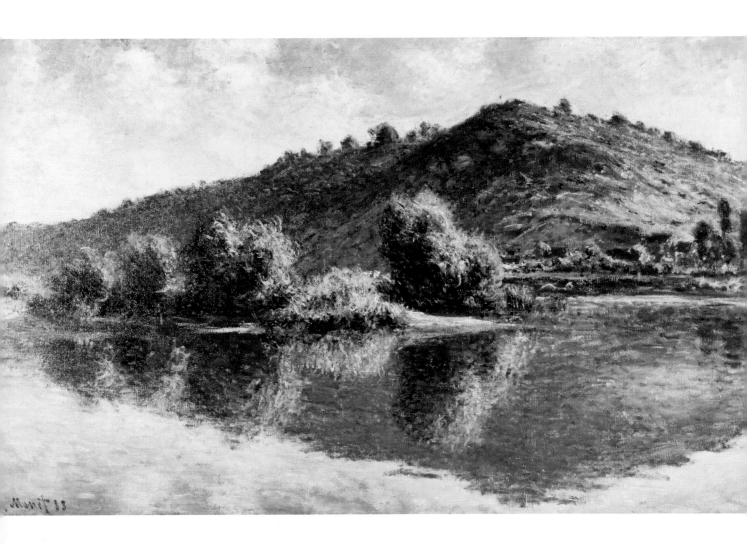

The Seine at Port-Villez, 1883
Private Collection/Photo © Christie's Images Ltd/The Bridgeman Art Library
Medium: Oil on canvas

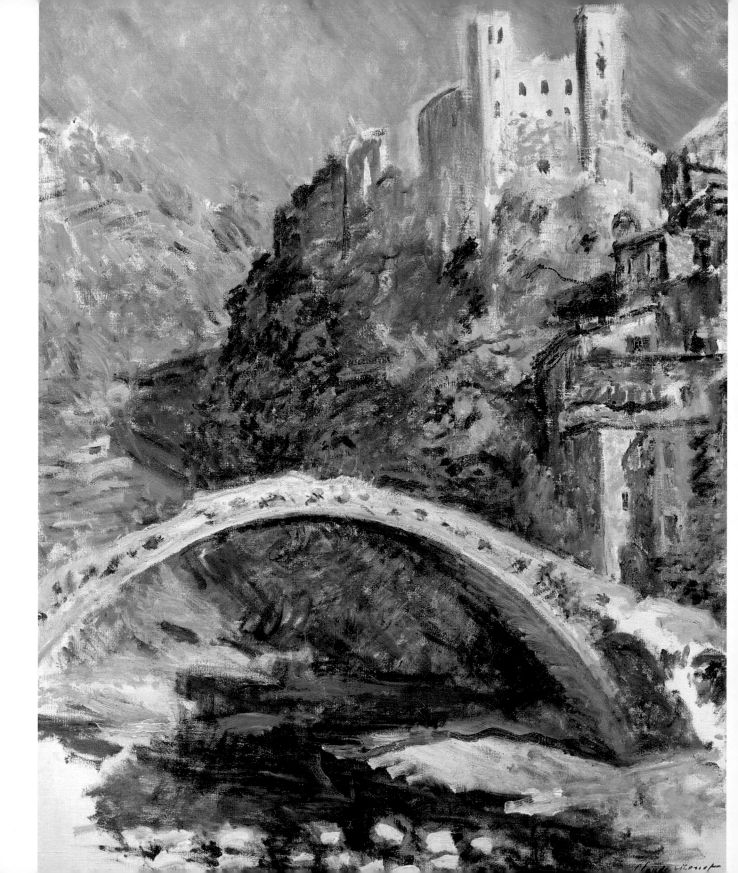

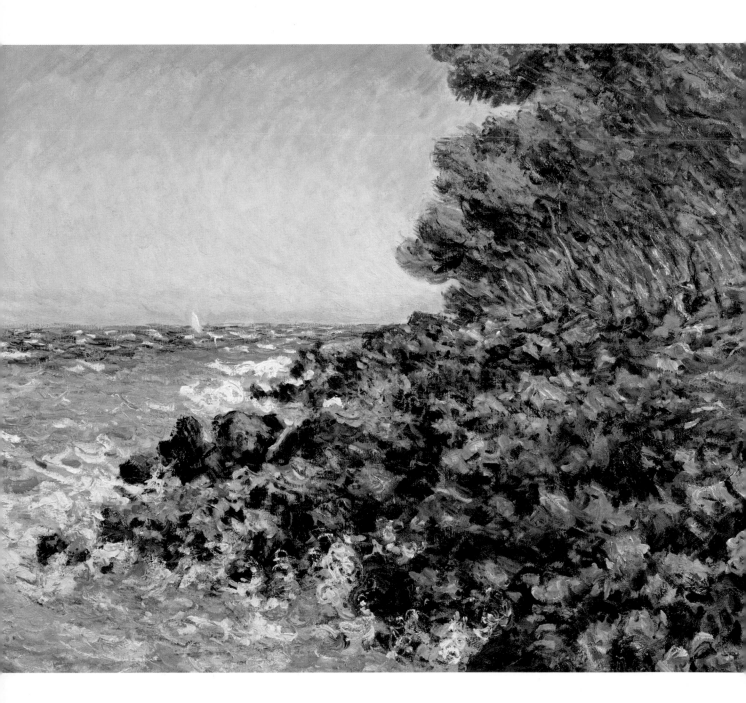

The Castle of Dolceacqua, 1884
© Musée Marmottan, Paris, France/The Bridgeman Art Library
Medium: Oil on canvas

Cap Martin, 1884
© Musée des Beaux-Arts, Tournai, Belgium/The Bridgeman Art Library
Medium: Oil on canvas

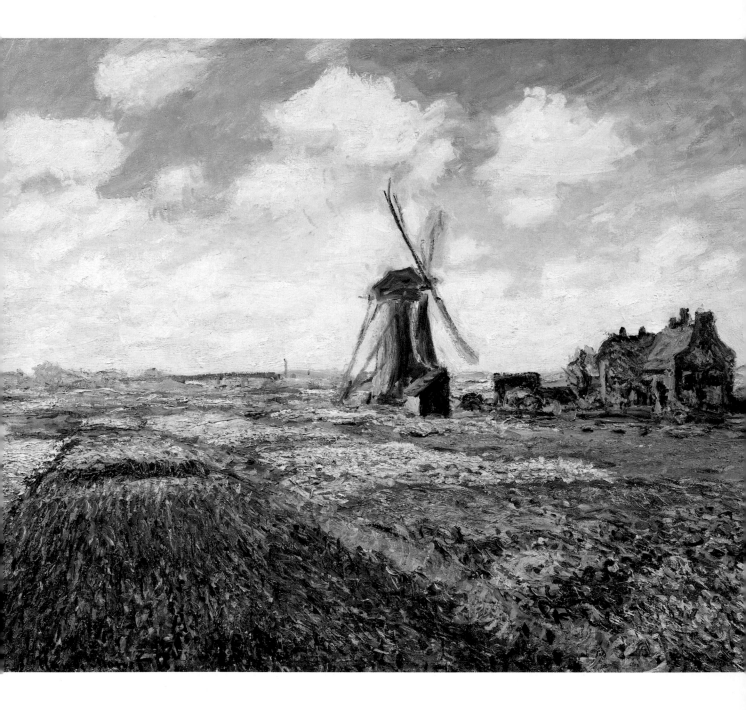

Tulip Fields with the Rijnsburg Windmill, 1886
© Musée d'Orsay, Paris, France/The Bridgeman Art Library
Medium: Oil on canvas

Self-portrait with a Beret, 1886
Private Collection/Photo © Lefevre Fine Art Ltd., London/The Bridgeman Art Library
Medium: Oil on canvas

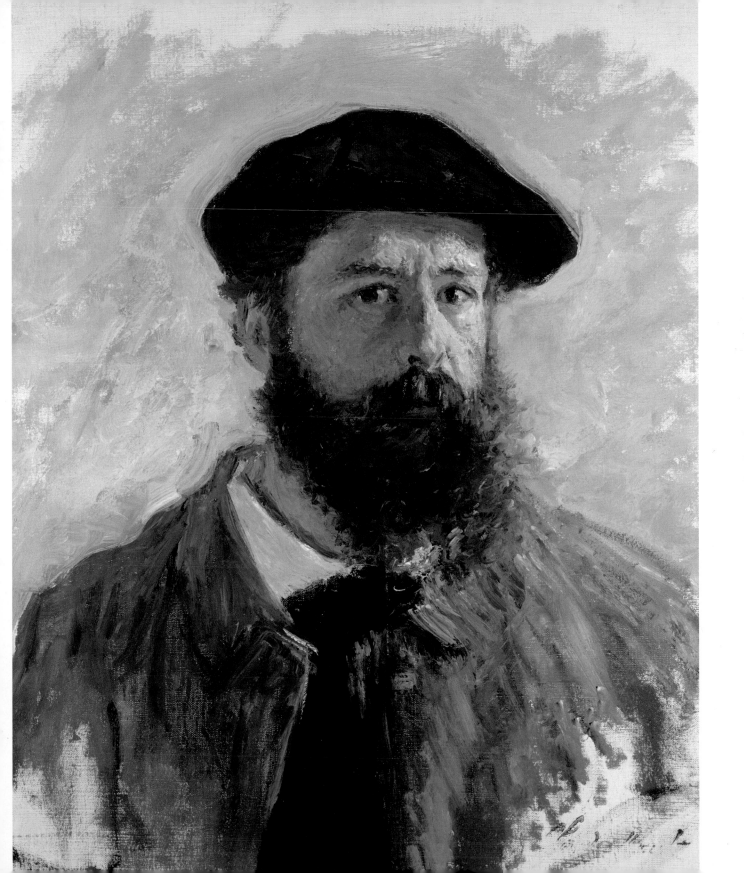

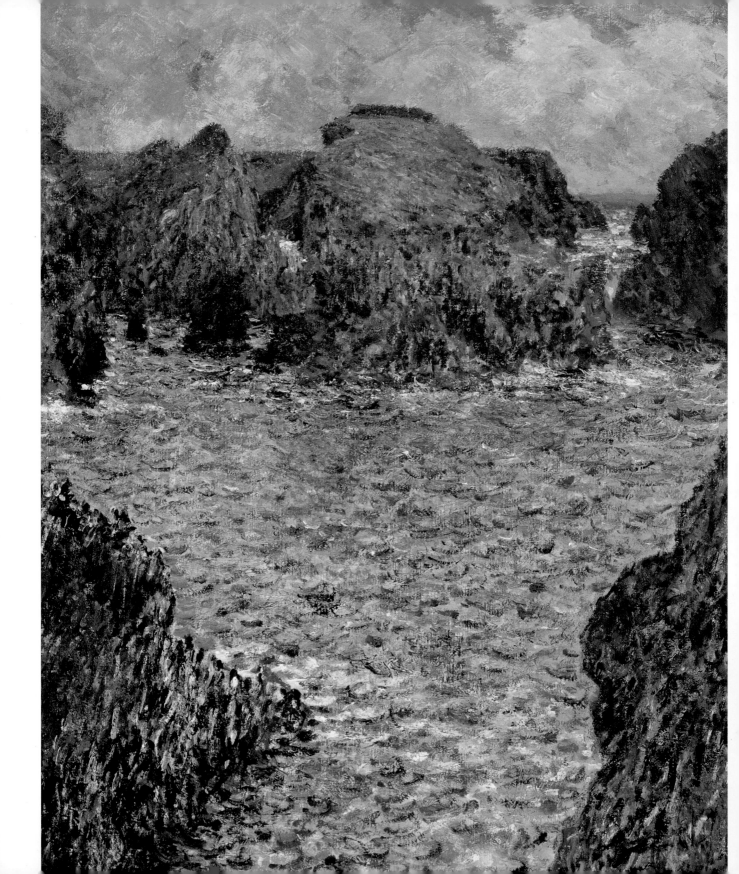

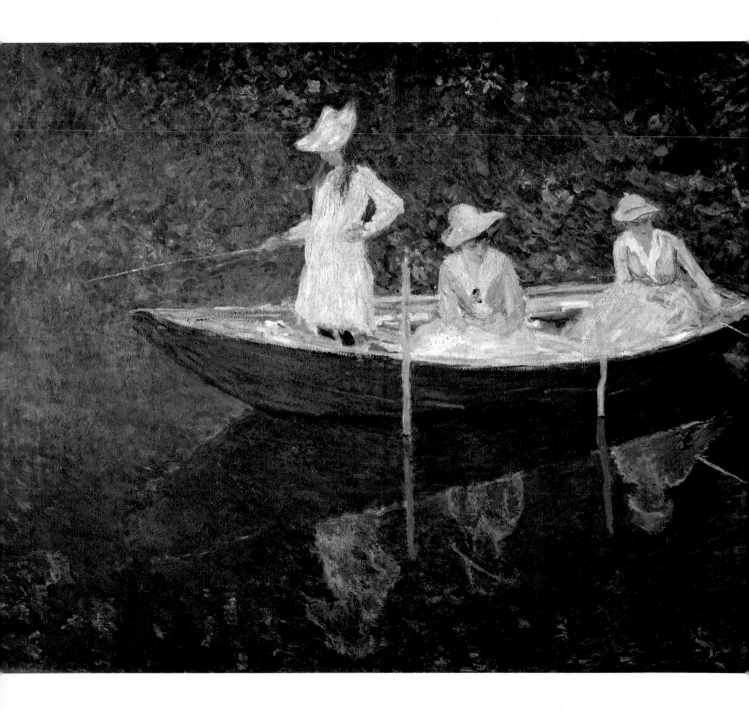

Port-Goulphar, Belle-Ile, 1887
© Art Gallery of New South Wales, Sydney, Australia/The Bridgeman Art Library
Medium: Oil on canvas

The Boat at Giverny, *c.* 1887
© Musée d'Orsay, Paris, France/Giraudon/The Bridgeman Art Library
Medium: Oil on canvas

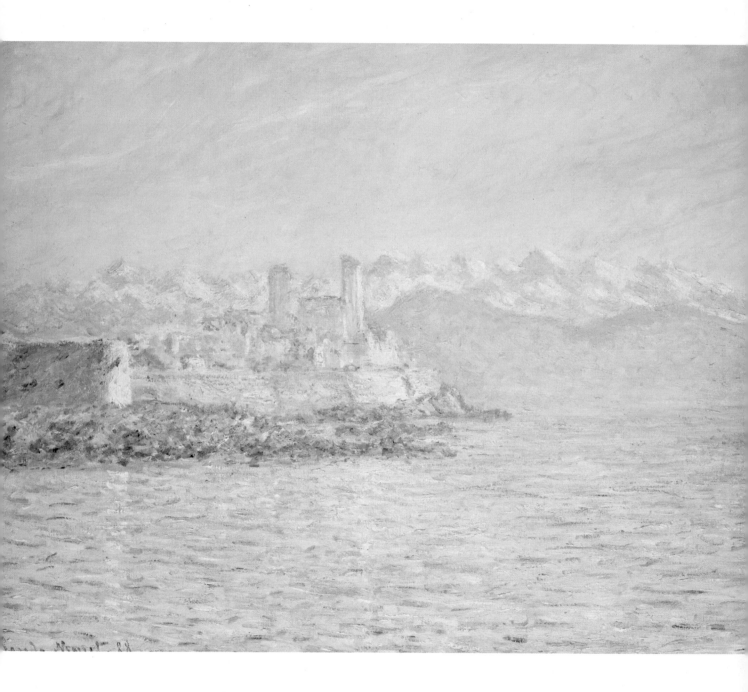

The Old Fort at Antibes, **1888**
Private Collection/Photo © Christie's Images Ltd/The Bridgeman Art Library
Medium: Oil on canvas

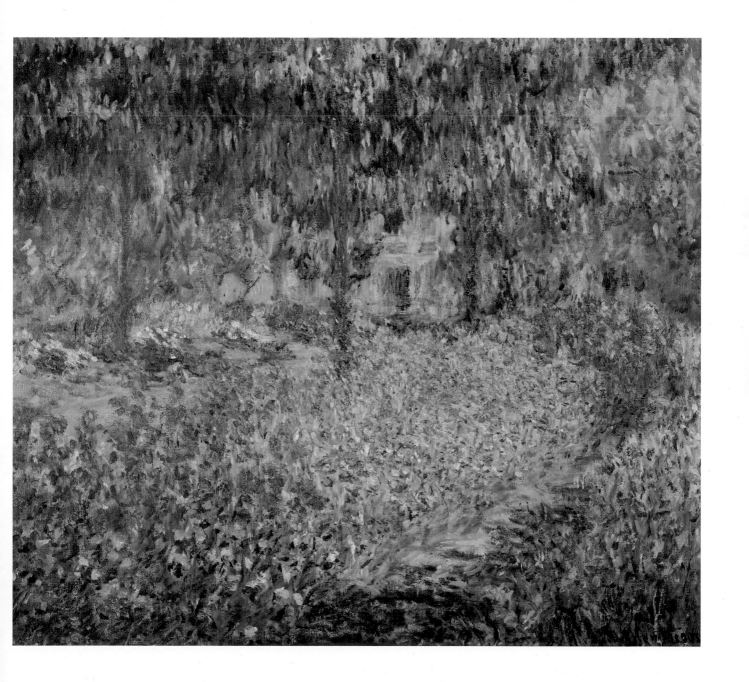

The Artist's Garden at Giverny, 1900
© Musée d'Orsay, Paris, France/Giraudon/The Bridgeman Art Library
Medium: Oil on canvas

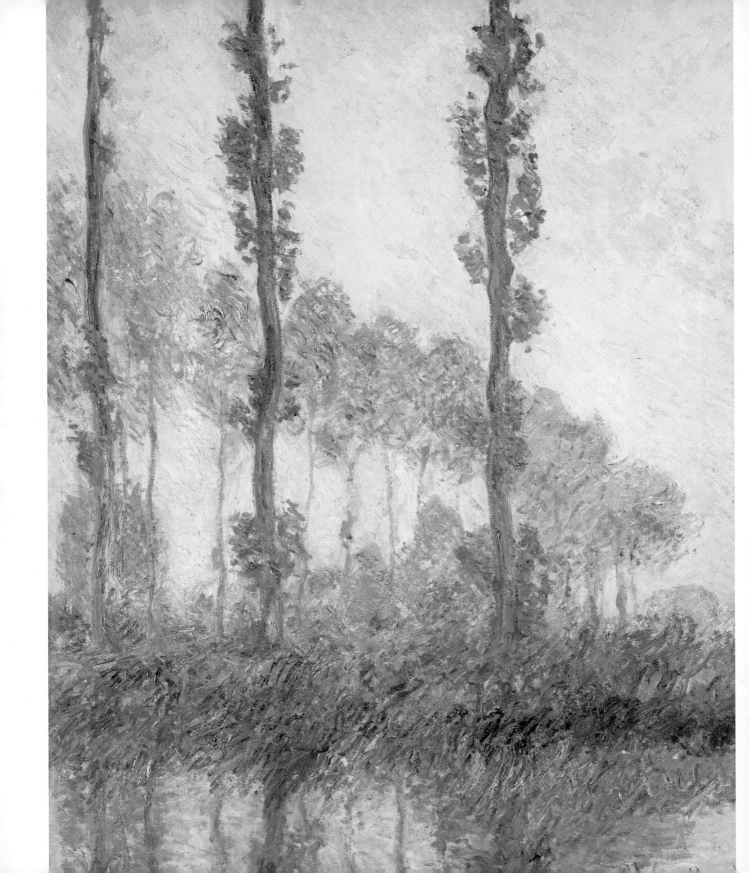

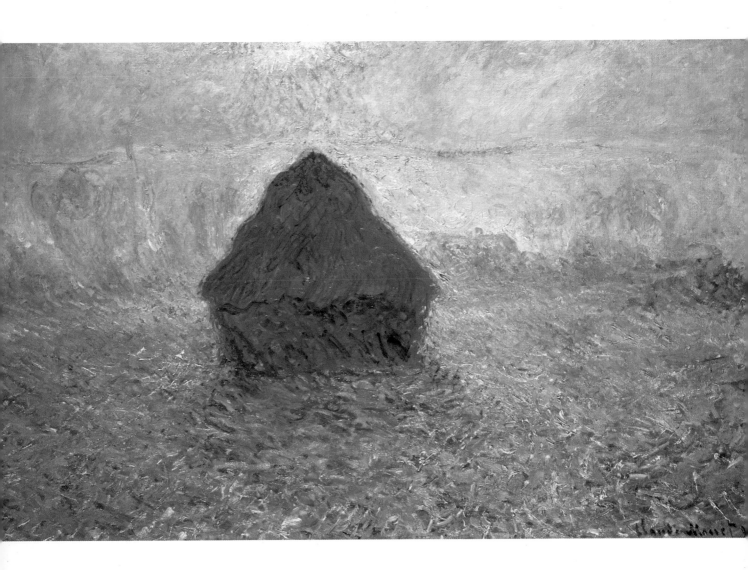

The Three Trees, Autumn, **1891**
Private Collection/Photo © Christie's Images/The Bridgeman Art Library
Medium: Oil on canvas

Haystacks, Hazy Sunshine, **1891**
Private Collection/Photo © Christie's Images/The Bridgeman Art Library
Medium: Oil on canvas

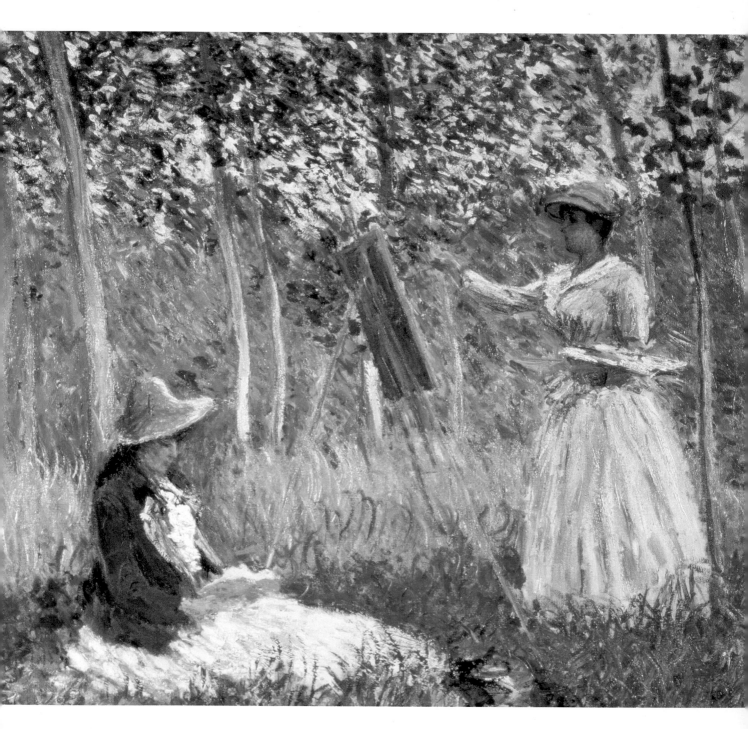

In the Woods at Giverny, **1887**
© Los Angeles County Museum of Art, California, USA/The Bridgeman Art Library
Medium: Oil on canvas

Rouen Cathedral in the Setting Sun, **1892–94**
© National Museum and Gallery of Wales/The Bridgeman Art Library
Medium: Oil on canvas

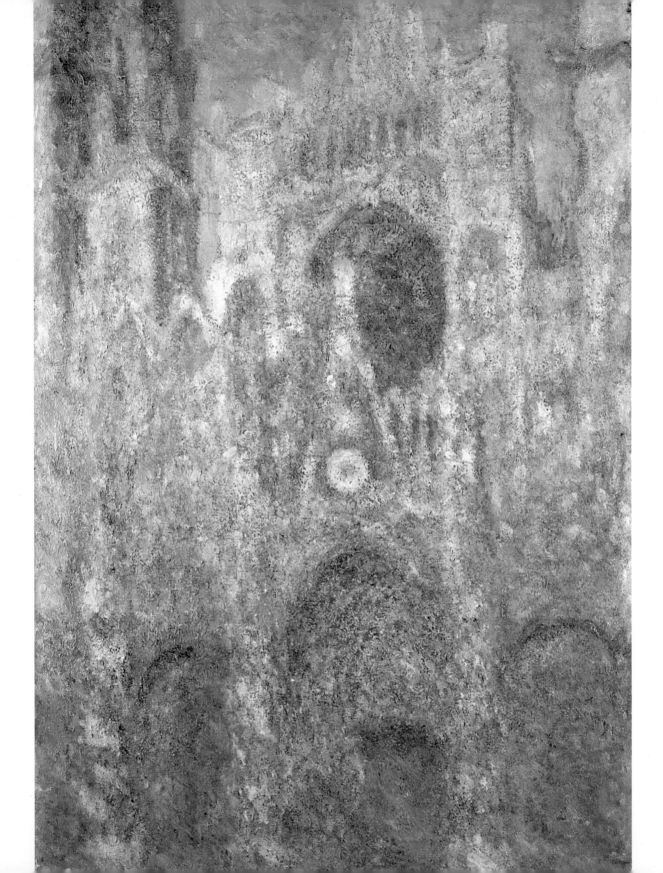

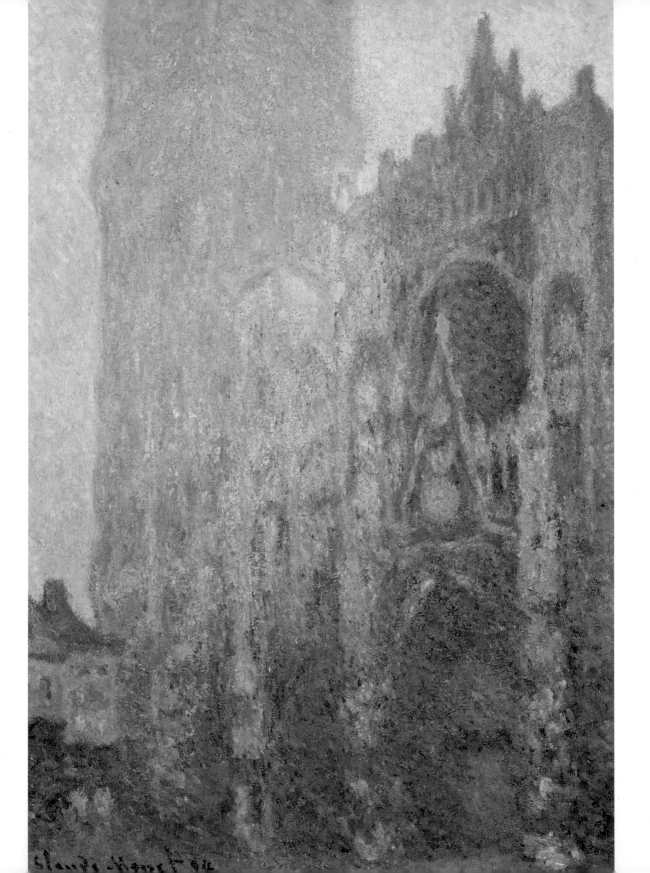

Rouen Cathedral Façade and Tour d'Albane,
Morning Effect, 1894
© Museum of Fine Arts, Boston, Massachusetts, USA,
Tompkins Collection/The Bridgeman Art Library
Medium: Oil on canvas

Vernon Church in Fog, 1893
Private Collection/Photo © Christie's Images/
The Bridgeman Art Library
Medium: Oil on canvas

(Next page) **Chrysanthemums, c. 1897**
© Private Collection/The Bridgeman Art Library
Medium: Oil on canvas

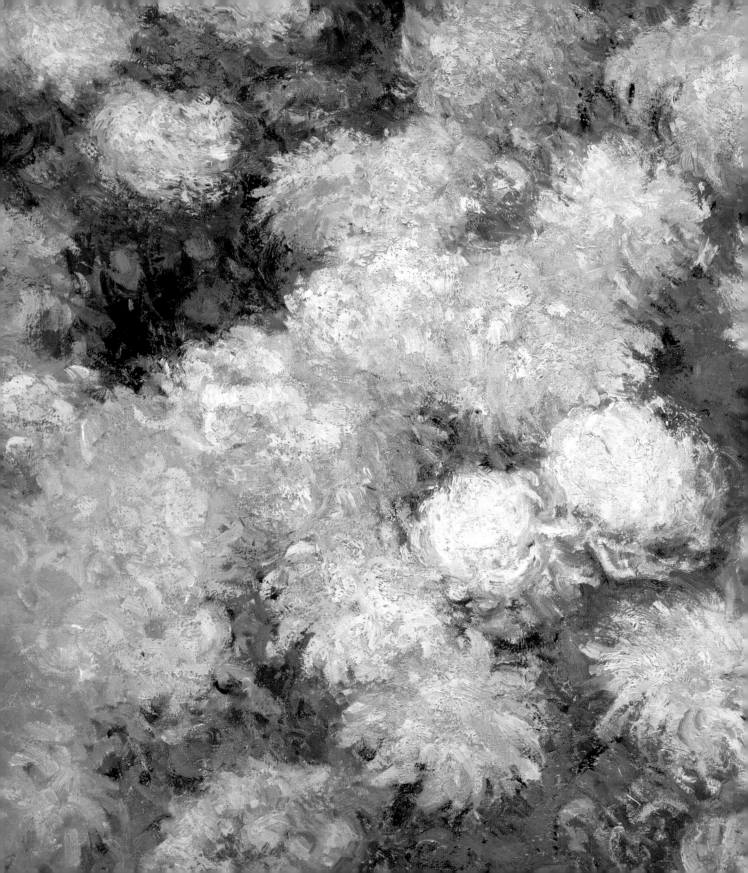

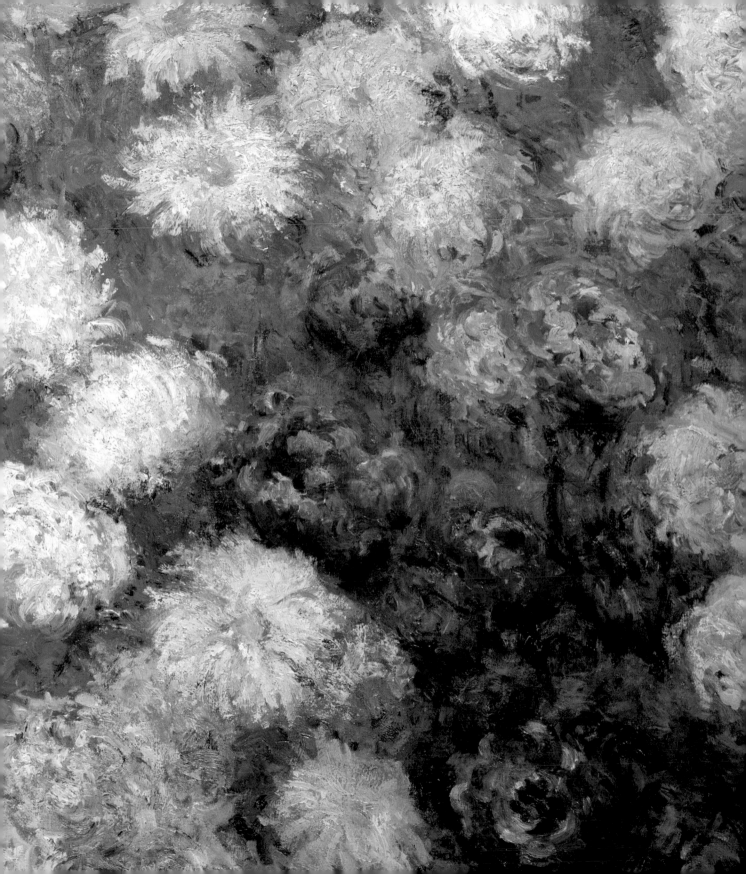

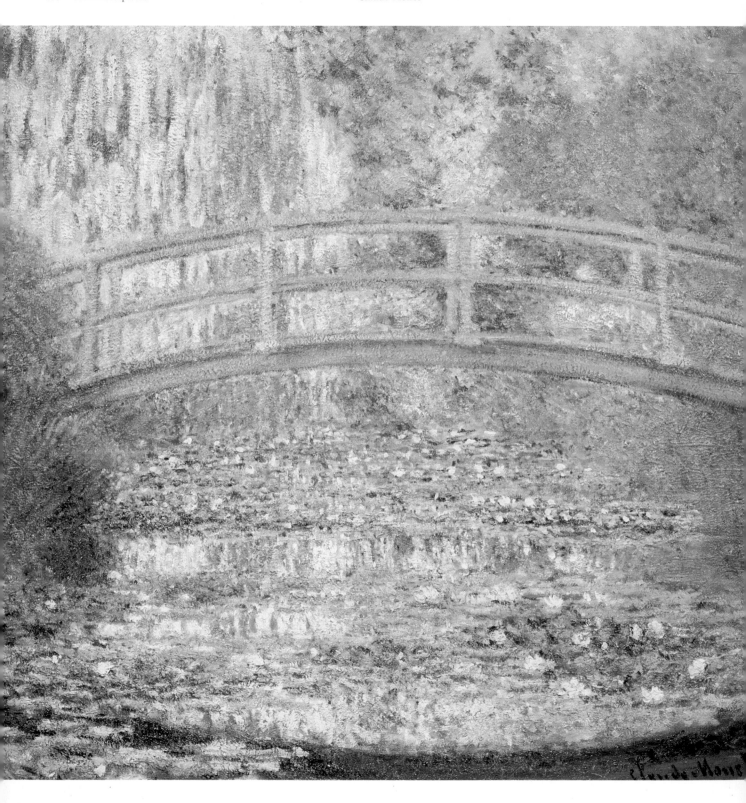

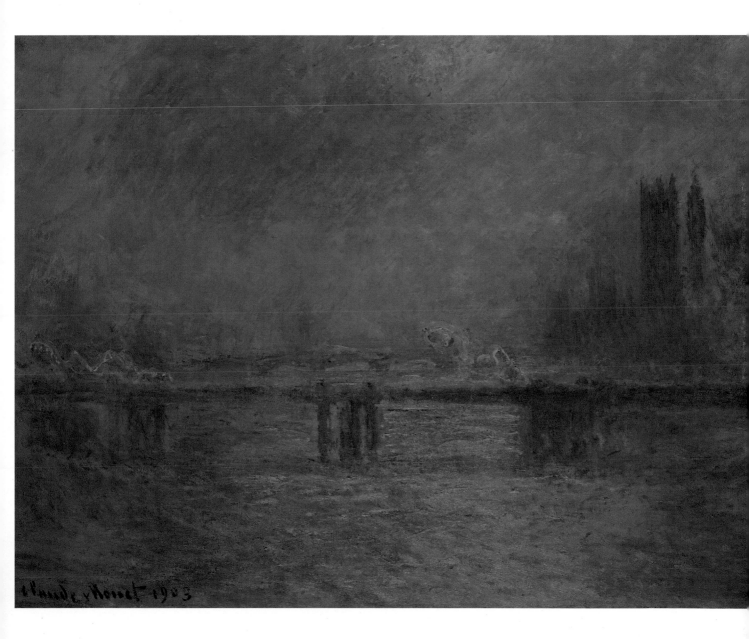

The Water Lily Pond with the Japanese Bridge, 1899
© Private Collection/Peter Willi/The Bridgeman Art Library
Medium: Oil on canvas

Charing Cross Bridge, The Thames, 1900–03
Private Collection/Photo © Christie's Images Ltd/The Bridgeman Art Library
Medium: Oil on canvas

- Claude Monet -

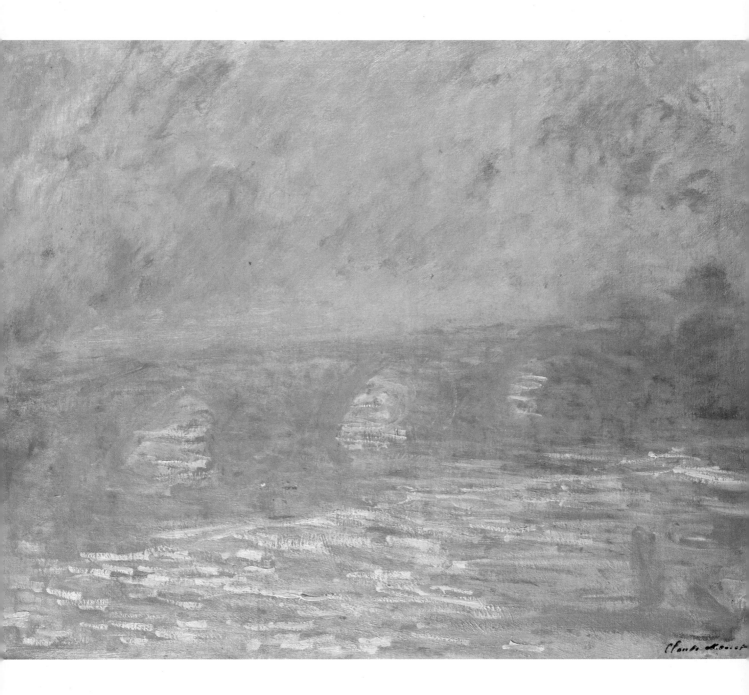

Waterloo Bridge, c. 1900
Private Collection/Photo © Christie's Images/The Bridgeman Art Library
Medium: Oil on canvas

Printemps à Giverny, 1903
© Christie's Images Ltd
Medium: Oil on canvas

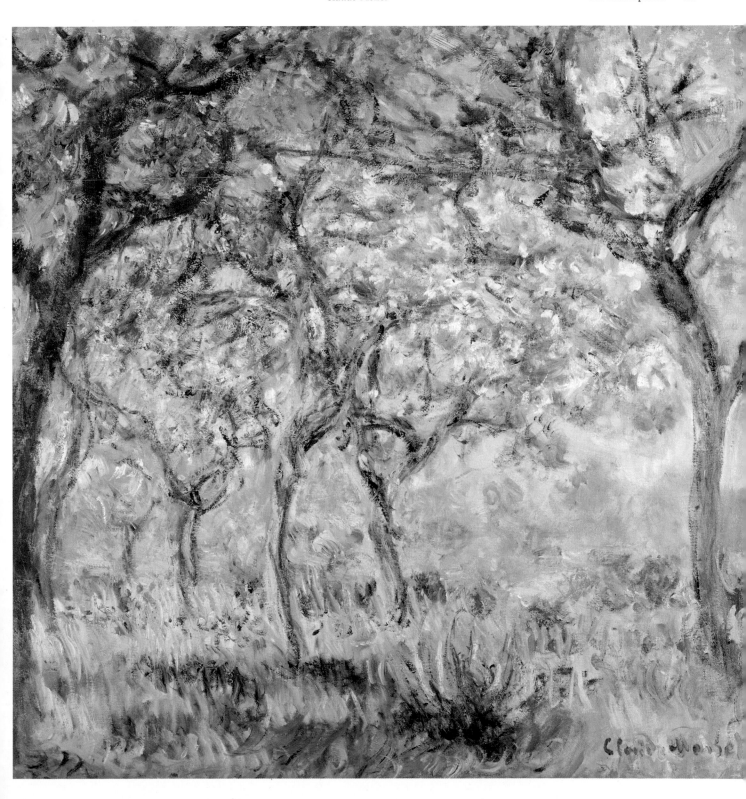

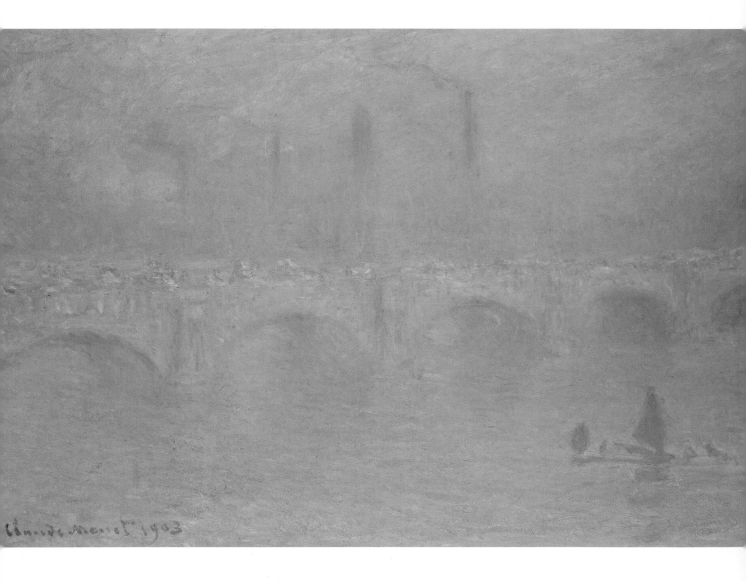

Waterloo Bridge, Soleil Voile, **1903**
Private Collection/Photo © Christie's Images/The Bridgeman Art Library
Medium: Oil on canvas

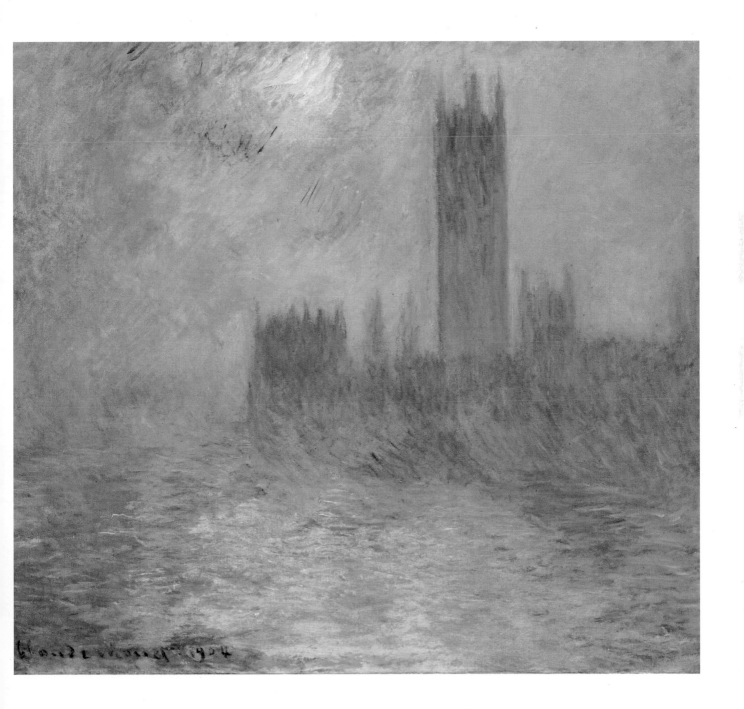

Parliament at Sunset, 1904
Private Collection/Photo © Christie's Images Ltd/The Bridgeman Art Library
Medium: Oil on canvas

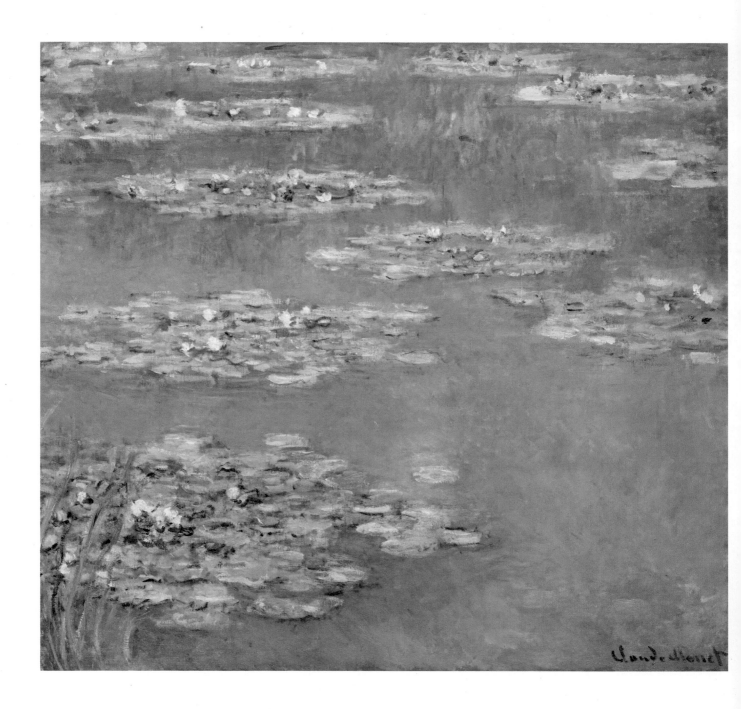

Water Lilies, c. 1905
Private Collection/Photo © Christie's Images/The Bridgeman Art Library
Medium: Oil on canvas

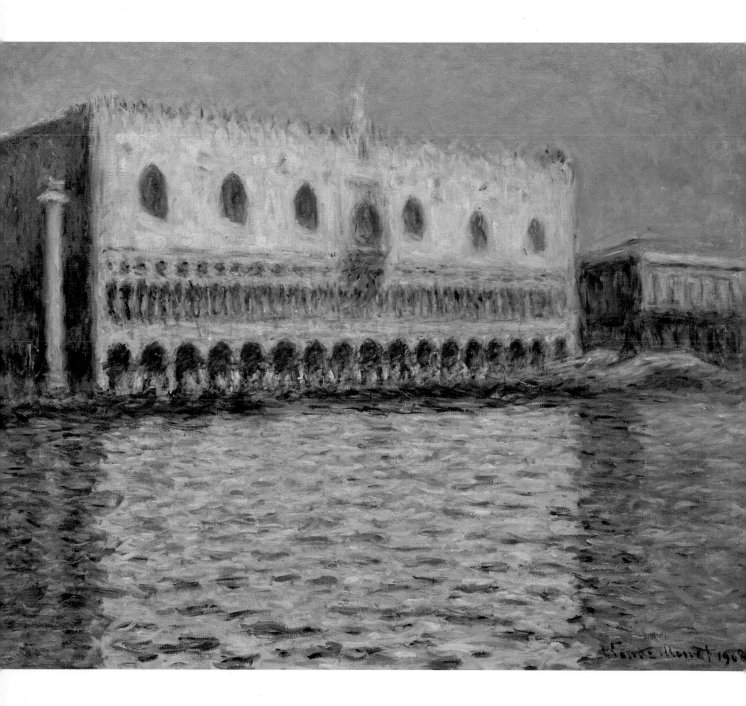

***The Doge's Palace in Venice,* 1908**
© Brooklyn Museum of Art, New York, USA/Gift of A. Augustus Healy/The Bridgeman Art Library
Medium: Oil on canvas

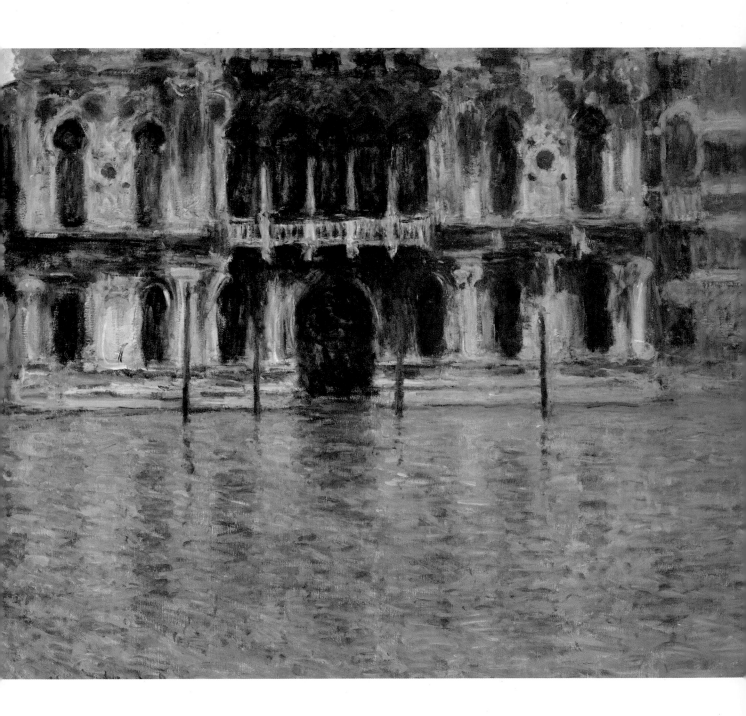

***Le Palais Contarini*, 1908**
© Christie's Images Ltd
Medium: Oil on canvas

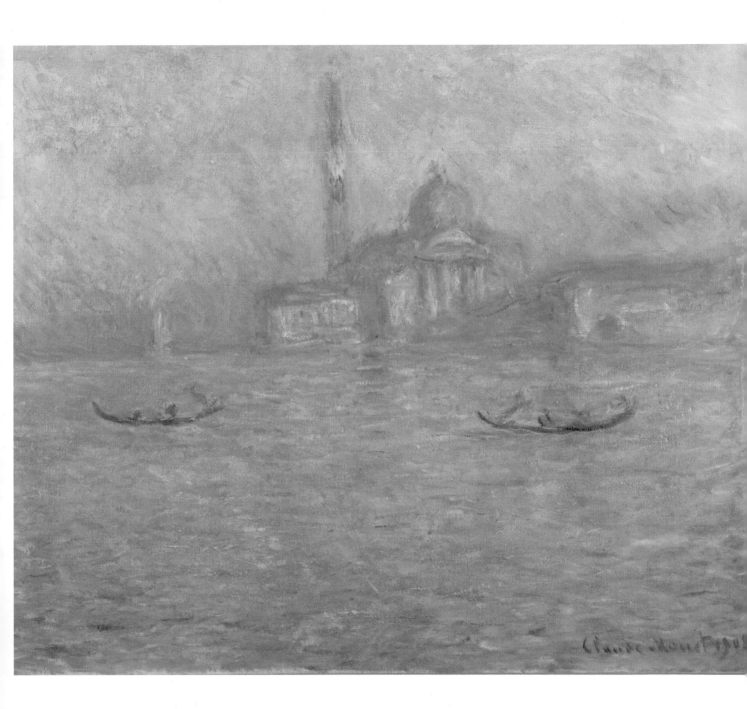

***San Giorgio Maggiore, Venice,* 1908**
© Private Collection, Phillips Fine Art Auctioneers, New York, USA/The Bridgeman Art Library
Medium: Oil on canvas

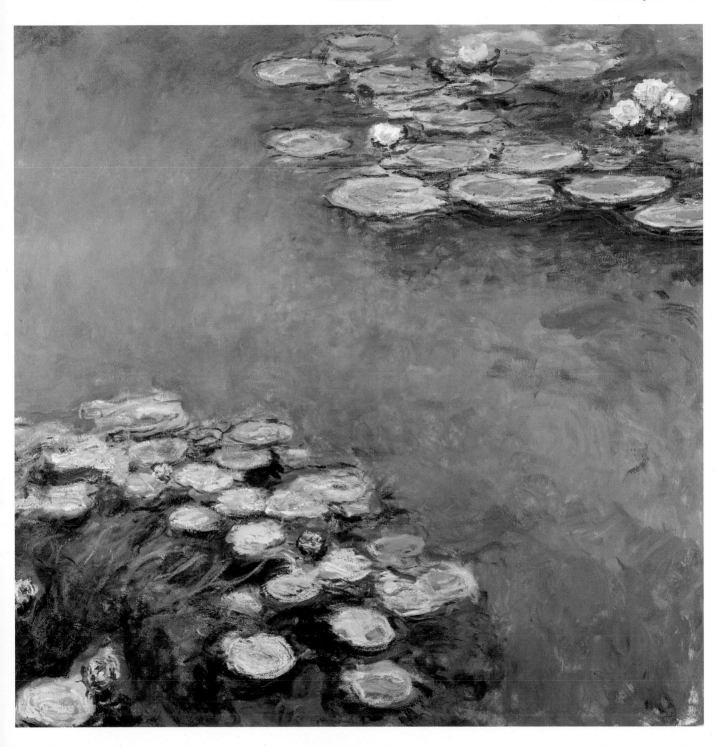

***Venice – Rio de Santa Salute,* 1908**
© Private Collection/The Bridgeman Art Library
Medium: Oil on canvas

***Water Lilies, Harmony in Blue,* 1914–17**
© Musée Marmottan, Paris, France/Giraudon/
The Bridgeman Art Library
Medium: Oil on canvas

(Next page) ***Water Lilies at Sunset,* 1915–26**
© Musée de l'Orangerie, Paris, France/Giraudon/
The Bridgeman Art Library
Medium: Oil on canvas

***The Artist's House from the Rose Garden,* 1922–24**
© Musée Marmottan, Paris, France/Giraudon/The Bridgeman Art Library
Medium: Oil on canvas

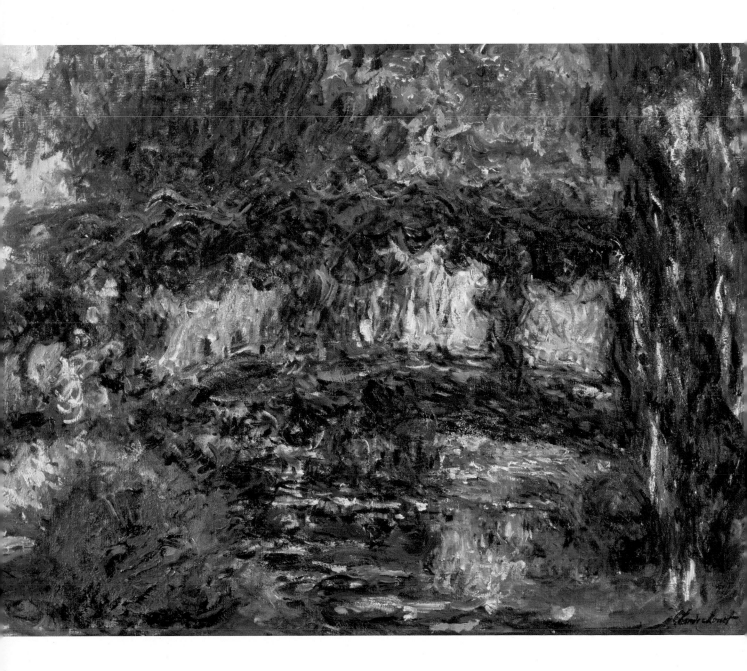

Water Lilies: The Japanese Bridge, or ***Japanese Bridge at Giverny,*** *c.* **1923**
© Minneapolis Institute of Arts, MN, USA/The Bridgeman Art Library
Medium: Oil on canvas

Index of Works

General Index

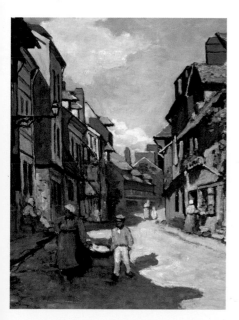

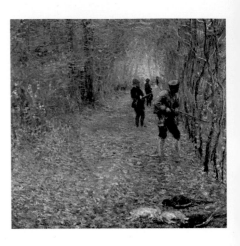

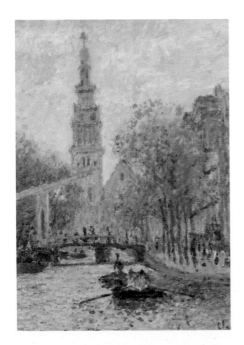